THE PSYCHOLOGY OF ADULT COLORING

How Coloring Creates Health and Healing

Blake LeVine, MSW

Skyhorse Publishing

Skyhorse Publishing books may be purchased in bulk at special discounts for sales promotion, corporate gifts, fund-raising, or educational purposes. Special editions can also be created to specifications. For details, contact the Special Sales Department, Skyhorse Publishing, 307 West 36th Street, 11th Floor, New York, NY 10018or info@skyhorsepublishing.com.

Skyhorse® and Skyhorse Publishing® are registered trademarks of Skyhorse Publishing, Inc.®, a Delaware corporation.

Visit our website at www.skyhorsepublishing.com.

10 9 8 7 6 5 4 3 2 1

Library of Congress Cataloging-in-Publication Data is available on file.

Cover design by Rain Saukas
Cover photo credit: iStockphoto

ISBN:978-1-5107-1763-3
Ebook ISBN: 978-1-5107-1764-0

Printed in the United States of America

CONTENTS

Introduction v

Chapter 1: The History of Coloring 1

Chapter 2: Why Is Art Therapy? 6

Chapter 3: Right Brain Coloring 12

Chapter 4: Mandalas Reducing Anxiety 18

Chapter 5: Relaxing for Improved Health 23

Chapter 6: Depression and Coloring 32

Chapter 7: Brain Health and Our Choices 39

Chapter 8: Releasing Problems 45

Chapter 9: Disconnecting from Technology 51

Chapter 10: A Deeper Look at Feelings 60

Chapter 11: A Substitute for Addictions 66

Chapter 12: The Meaning of Colors 71

Chapter 13: Finding Light in Creativity 79

Chapter 14: The Artist Struggles 85

Chapter 15: Creating a Coloring Group 91

Chapter 16: Mixing Meditation and Coloring 101

Chapter 17: Healthy Escapes 107

Chapter 18: Parenting, Coloring, and Kids 113

Chapter 19: Liberation of Your Life 121

Chapter 20: Letting Go 127

Chapter 21: Creating an Adult Coloring Teaching Lesson 132

Chapter 22: A Coloring Experiment 139

Chapter 23: The Starving Artist 145

Chapter 24: Art is a Part of Us 151

Chapter 25: Learning to Change May Be Strange 157

Chapter 26: A New Path Forward 167

Chapter 27: Art Quotes 172

Chapter 28: More Questions than Answers 186

Chapter 29: Real Progress Takes Time 191

Chapter 30: Coloring and Hope 195

About the Author 200

Resources 203

Acknowledgments 204

Disclaimer 205

INTRODUCTION

Pablo Picasso said, "Every child is an artist. The problem is how to remain an artist once we grow up." In our fast-paced modern life that question has grown increasingly important. Most of us can't afford a two-week vacation in a luxury hotel on a private island whenever things get a little stressful. We can, however, pick up a coloring book and enter a world of imagination and calm.

It is clear that adult coloring has become an active interest for millions of adults. I began to wonder, "What is the psychological reason so many of us find peace, enjoyment, and hope when coloring?" My goal is to look deeply at why we feel such a connection to this creative outlet.

In my own life, I use coloring and art as tools. This week, my children were filled with energy, and I had a work problem that felt very frustrating. I started to examine the different options to handle my anger and thoughts. I chose to take my kids into my garage and engage in art. My seven-year-old daughter, Tyler, began sculpting with the Crayola clay I bought her at Toys R Us. My son is only two, but he

began scribbling with a marker on a large piece of paper. I took my adult coloring book and began to fill it in. As I was doing this, a sense of calm overtook my brain. The fears and problems on my mind began to dissipate. I was letting go of the issues and allowing myself to heal through coloring.

This is not the first time I have used art as a tool to help make a positive difference. I was about twenty-five when I entered school at Adelphi University in Garden City, New York. I was working towards a Master's Degree in Social Work. As part of my training, we had an internship to practice our therapeutic techniques. I was placed to work at a psychiatric hospital in Amityville, New York. I arrived at the dilapidated hospital to find a group of mostly inner-city youth as my patients. I could sense right away that they didn't like therapists and opening up about their emotions.

During our work, they eventually shared their sad experiences: Losing a dad to suicide when he jumped off a building; having parents arrested for drug dealing; seeing their moms shoot up heroin and die; being sexually abused; and the constant struggle of being in the foster care system. This meant that by age twelve, some had lived in as many as ten homes. They talked about foster siblings bullying them, having parents throw them out, and sometimes feeling unloved. I felt that these children had faced more challenges than any young person should experience. Art, in all its many forms, helped them open up.

I found that this group touched my life. When I graduated, I made it my mission to spread this work and message. I ended up creating a documentary, *Rap Therapy* (2013), with The Salvation Army. They are the largest organization overseeing foster children in New York State. We worked

over six weeks to help a group of teenagers use art and music as therapy. I also interviewed many notables from 50 Cent and Russell Simmons to Tom Cruise to talk about how rap and art can be a powerful form of therapy for the youth.

I have written several books about mental health addressing a range of topics: bipolar disorder, depression, addiction, and parenting. In this book I want to take the coloring fascination and shine a bright light on why it is helping so many of us. I know these last few years have been financially and emotionally difficult for many of us. I think I am not alone in searching for tools to alleviate the real pressure and stress many of us face.

I believe that coloring and art represent a valuable part of our lives. I want this book to share how we can use adult coloring as a tool to face our problems and ease our anxiety. When you are trying to cope with hard times, having access to a healthy outlet is vital. You may be living with fears about financial, emotional, or relationship issues. I hope this book will provide a better understanding of why we are so connected to coloring. You are never too old to release your inner child. Finding a creative way to express your emotions may lead to a healthier way of looking at the world.

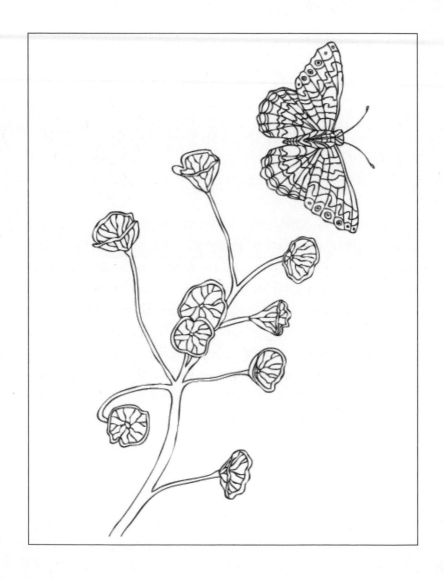

Chapter 1

The History of Coloring

Many of us enjoy using Crayola crayons for our children and in our own coloring. Although there is no confirmed date about the origin of crayons, some sources suggest 1644 marks the earliest use of the word "crayon." The definition means "coming from chalk" and the Latin word *creta* which means "earth."

There are many examples of some of our greatest artists using crayons in their work. The artist Francois Clouet lived in the 1500s and used crayons in his early art. It is believed that he caught the attention of Henry V, and ended up becoming a painter for the royalty of that day. In modern times, countless numbers of our greatest artists also used crayons. In 1972, Pablo Picasso used crayons and pencils to create a late work titled *Self Portrait Facing Death*. *The Scream*, by Edvard Munch, depicts a figure that is in agony along with beautiful colors in the background. A pastel version of this 1895 painting sold at an auction in London in 2002 for 119.9 million dollars.

Many of us grew up using Crayola Crayons. Crayola is the popular brand name most of us know best. The famous

name Crayola was coined by Mrs. Edwin Binney. Alice Binney put together the French word "craie," meaning "stick of chalk" and "ola" from the word "oleaginous," meaning "oily." This simple idea became a lasting legacy. The Crayola brand has been around over one hundred years and the company has sold billions of these crayons.

Other tools used in adult coloring include colored pencils, markers, and paint. Coloring has benefited artists, children and creative works for many years. The coloring book has long been a creative staple for many of us. It is believed that the idea of using a coloring book was first discussed by British artist Joshua Reynolds in a series of lectures. Swiss teacher Johann Heinrich Pestalozzi and one of his students, Friedrich Frobel, both believed art instruction helped children learn.

"Drawn to Art: Art Education and the American Experience," a booklet published by the Huntington Library (2003), outlines the history of these concepts. According to the author, Diane Korzenkik, educators and social reformers of the nineteenth century believed art was an important way to help educate. They used different types of art to help improve the workforce. "Art also provided students with a medium for spiritual enrichment and the understanding of self," says Cathy Cherbosque, curator of historical prints and ephemera at the Huntington Library and curator of an exhibition on this subject: "Over the course of the twentieth century, educators increasingly promoted the notion that children learn to see their artistic creations as reflections of self. Art-making provided opportunities to relate that self to other individuals and cultures."

John McLoughlin was born in 1827 and began working on coloring books with his brother Edmund. In the 1880s,

working with Kate Greenaway, the McLoughlins produced *The Little Folks' Painting*. Credited as the inventors of the first coloring book, John and Edmund started a company called McLoughlin Bros., a New York publishing firm. The company created many titles, including children's books and board games, eventually becoming part of The Milton Bradley Company.

Many important figures have used coloring or drawing to help their lives, even American presidents. An article in *The Atlantic* from September 2006, titled "All The Presidents' Doodles," shares that many presidents would draw in the White House. Thomas Jefferson, Andrew Jackson, Theodore Roosevelt, Dwight Eisenhower, John Kennedy, and George Bush are just some of these Oval Office artists. There are even reports of Dwight Eisenhower drawing or doodling during cabinet meetings.

Not surprisingly, many celebrities and historical figures have been drawn to creating art. Michael Jackson, Paul McCartney, Frank Sinatra, Marlon Brando, Anthony Quinn, Tony Bennett, Bob Dylan, Prince Charles, and even Sylvester Stallone are just some of the many well-known celebrities who seek inner peace and refuge from the outside world through art and coloring. Albert Einstein famously stated, "The most beautiful experience we can have is the mysterious. It is the fundamental emotion that stands at the cradle of true art and true science." I think he knew that expressing our creative abilities could lead to a happier existence.

The idea of creating art has been around for centuries. There is consensus that workmanship with artistic elements existed 40,000 years ago, but debate persists about the first

use of art. Most evidence suggests that 500,000 years ago simple art was made by *Homo erectus*.

Is this one of the reasons adult coloring feels so valuable? Do we have a prehistoric disposition toward using our minds to create projects? Is it possible that the therapeutic value in creating has allowed coloring to be a modern phenomenon? In a society so consumed by computers and technology, it is strange that simple books we color in have captured our attention and redirected our energy.

Chapter 2

Why Is Art Therapy?

The term "art therapy" was coined in 1942 by the artist Adrian Hill. Adrian was in a sanitarium for an illness when he discovered the value in drawing and painting. He said in his book, *Art Versus Illness,* that

> Isolation from the community, no doubt, evokes a more contemplative attitude towards life, and while the patient's animal ego is quiescent, the spiritual of subliminal essence, hitherto cramped by a humdrum environment, is allowed free play in producing works of considerable imagination, both of an idealistic and necrotic nature.

Hill would go on to spend much of his energy spreading ideas about art as therapy, eventually becoming President of the British Association of Art Therapists.

There have been many who have found support by creating art. I remember living in Manhattan across the street from the Ronald McDonald House Charity. It was so sad to

see children ages four and younger battling severe cancers. I would watch them and their parents walking through my neighborhood for treatment at the Memorial Sloan Kettering Cancer Center. Studies have shown that medicine combined with creative outlets, such as art therapy, can have a can have a powerful, beneficial impact on cancer patients.

The article "Effects of Creative Arts Therapies of Psychological Symptoms and Quality of Life in Patients With Cancer" was published in JAMA Internal Medicine in May of 2013. The researchers found that "Creative arts therapies (CATs) can reduce anxiety, depression, pain, and fatigue and increase quality of life (QOL) in patients with cancer."

There are many other examples of art therapy helping those who face pain. There is a belief that those in treatment for addiction may benefit from art therapy. The study "Breaking Through: Incident Drawings with Adolescent Substance Abusers," revealed that:

> The initial aim of treatment is to break through the denial of the adolescent. This breakthrough may be facilitated through the use of drawings in a group to access emotions that may have been intellectualized. The goal is to get the patients to deal with a sufficient number of incidents in order to gain insight into their disease. The content of these drawings often includes themes of destruction, loss, shame, and guilt. As recovery continues, incident drawings are used to focus on the development issues of adolescence, as well as feelings that may have been masked by Chemicals.

Even though art therapy is a relatively new type of treatment, it has already made a great contribution in helping patients. I have found in my own life that creating art, writing, drawing, coloring, and rapping have helped me deal with my emotions. I remember my first psychiatric hospitalization at age fifteen. During that time, I was very depressed about my circumstances. We would sometimes create art in the hospital, and all of the patients looked forward to the activity. It helped us open up and express the severe pain we were facing.

Part of human nature is expressing ourselves. We have a need and desire to open up about what we feel. This may be why creating, listening, and looking at art is both therapeutic and important for our lives.

Walt Disney said, "Of all our inventions for mass communication, pictures still speak the most universally understood language." This may be why, even 40,000 years ago, our ancestors were drawing in caves. The pictures we see, draw, and create move us in some undefined manner. Disney also said, "You can design and create, and build the most wonderful place in the world. But it takes people to make the dream a reality." This is why, when placed with a group of peers, drawing and creating may help those in a psychiatric hospital to make progress. Even if severely ill, being with others and using their artistic nature can soothe and support positive growth.

I believe that all of us can use art as therapy. It may mean finding what type of creation feels best for you. There are some who have such artistic ability that they can draw landscapes, the human form, and a vast number of items. There are others who have less artistic ability yet still have a desire

to create. This may mean coloring, doodling, using clay, or finding a medium that feels fun.

The American Art Therapy Association is an "organization of professionals dedicated to the belief that making art is healing and life enhancing." On their website they note:

> Art therapy is an integrative mental health profession that combines knowledge and understanding of human development and psychological theories and techniques with visual arts and the creative process to provide a unique approach for helping clients improve psychological health, cognitive abilities, and sensory-motor functions. Art therapists use art media, and often the verbal processing of produced imagery, to help people resolve conflicts and problems, develop interpersonal skills, manage behavior, reduce stress, increase self-esteem and self-awareness, and achieve insight.

If you want to learn about art therapy or becoming an art therapist, please see *arttherapy.org*. The American Art Therapy Association is a fabulous group dedicated to helping advance art as therapy. Naturally, most people casually coloring are not about to embark on a career change and go into art therapy, but perhaps just knowing how the simple act of coloring can offer so many positive results is enough. And for those who do find the prospect of expanding their hobby into something more, it may be one of the best careers for someone with both a creative nature and a gift for helping those with emotional issues.

Art as therapy will continue to be a growing field. I have no doubt that many future generations will learn about the healing powers of harnessing our creativity. It is possible that many physical ailments may benefit from the use of these therapeutic tools, too. I hope there may be a time when all hospitals, schools, and treatment centers will use art therapy.

Chapter 3

Right Brain Coloring

"There probably is no more important quest in all science than the attempt to understand those very particular events in evolution by which brains worked out that special trick that has enabled them to add to the cosmic scheme of things: color, sound, pain, pleasure, and all the other facets of mental experience."

—Roger Wolcott Sperry

We know how powerful our brains are, yet the science of our minds is relatively new. Roger Sperry won a Nobel Prize for his work on split brains. In an article by Norman H. Horowitz on the Nobel Prize official website, Horowitz notes that "Sperry and his students showed that if the two hemispheres of the brain are separated by severing the *corpus callosum* (the large band of fibers that connects them), the transfer of information between the hemispheres ceases, and the coexistence in the same individual of two functionally different brains can be demonstrated. The findings contradicted

the generally held view—again based on misinterpretation of evidence—that sectioning of the *corpus callosum* produced no definite behavioral effects. The probable explanation is that the two hemispheres, although separated from one another, are usually in agreement, so that no obvious conflict results. By means of ingenious tests, however, Sperry and his group showed that definite behavioral phenomena can be demonstrated following the brain-splitting operation."

Sperry began his work with monkeys and cats. It eventually expanded to human patients who had surgically separated hemispheres. The goal was to help control intractable epilepsy. This group of patients allowed him to show there is a conscious mind within each hemisphere. The right hemisphere is mute and capable of basic addition is superior in reading maps or recognizing faces. The left hemisphere deals with speech and is dominant in arithmetic, analysis and spoken language. Before these patients were studied there was a doubt if the right hemisphere was conscious. By devising experiments to communicate with the right hemisphere Sperry's work to quote him: "indeed a conscious system in its own right, perceiving, thinking, remembering, reasoning, willing, and emoting, all at a characteristically human level, and . . . both the left and the right hemisphere may be conscious simultaneously in different, even in mutually conflicting, mental experiences that run along in parallel."

It would be easy to say that our right brain controls creative use and the left brain is focused on analytical and verbal thoughts. There is a debate among scientists that study these types of brain science. In popular culture, there is talk of some of us being more right-brained and having greater

creative abilities, but some in the research community have their doubts. A popular article in *The Guardian*, written by Amy Novotney, is titled "Despite what you've been told, you aren't left brained or right brained." Amy writes,

> In a new two-year study published in the journal *Plos One*, University of Utah neuroscientists scanned the brains of more than 1,000 people, ages 7 to 29, while they were lying quietly or reading, measuring their functional lateralization—the specific mental processes taking place on each side of the brain. They broke the brain into 7,000 regions, and while they did uncover patterns for why a brain connection might be strongly left- or right-lateralized, they found no evidence that the study participants had a stronger left- or right-sided brain network.

Her article also observes that some studies show that left brain and right brain are not perfectly accurate. She shares the results of the study "Exploring the neural correlates of visual creativity" by Liza Aziz-Zadeh, Sook-Lei Liew, and Francesco Dandekar. They found that,

> Although creativity has been called the most important of all human resources, its neural basis is still unclear. In the current study, we used fMRI to measure neural activity in participants solving a visuospatial creativity problem that involves divergent thinking and has been considered a canonical right hemisphere task. As hypothesized, both the visual creativity task and the control task as compared to rest activated a variety of

areas including the posterior parietal cortex bilaterally and motor regions, which are known to be involved in visuospatial rotation of objects. However, directly comparing the two tasks indicated that the creative task more strongly activated left hemisphere regions including the posterior parietal cortex, the premotor cortex, dorsolateral prefrontal cortex (DLPFC) and the medial PFC. These results demonstrate that even in a task that is specialized to the right hemisphere, robust parallel activity in the left hemisphere supports creative processing.

So what causes us to enjoy coloring? Are the more artistic born with a brain ready to engage in art? Do some of us find coloring stupid and others love it with a passion? Our brains are so complex that even the brightest minds have trouble figuring it all out. It would be wrong to assume we can make a blanket statement that shows how each human brain works. What is often the case, however, is that memories of joy when we colored as a child come back again when we color as an adult, lighting up the inner child who remembers those good old days.

Neil deGrasse Tyson is a cosmologist, astrophysicist, author, and science expert. During an interview with *Fast Company*, he said, "I'm disappointed with some aspects of civilization. One is our unending urge to bypass subtlety of character, thought, and expression and just categorize people . . . If you want to understand who and what a person is, have a conversation with him." He later said, "I'm 'brained.' Not right-brained or left-brained. I have a brain."

It may be that Neil is correct. We often look to categorize or create simple solutions for complex problems. It would be

great to have an easy way to understand how our minds learn and process information. I have found that mental health is too complex to have a consensus. I take medication for a mental illness despite not knowing exactly how it helps my brain. I will not deny that it took years to find the correct dosage after trying many types of treatments. Wouldn't it be better if we could accurately pinpoint exactly what is happening in a brain? I know less of us would suffer and struggle to enjoy life.

This explains why we are always in need of research. We live in a modern society filled with fascinating technology. You can be in Florida video-chatting on your computer with someone in China in moments. Why can we not understand how our minds work, process, and flow? My son with language processing problems takes therapy each week with a counselor. What would happen if I knew exactly what is going on in his mind? Would I be able to teach him how to talk more or find a treatment that would help him progress? Are families with an autistic or a mentally ill child the only ones who would benefit from this? What would it mean for our world if we had answers to these complex questions?

I can only say that coloring is a simple joy that can seem basic. When we face pressure and pain, our whole brain deals with the reality. Taking time to be creative helps us in a myriad of ways. We can express, release, and let ourselves feel peaceful. In youth we often live simply and without complex reasoning. This may be why letting ourselves be a kid again is allowing coloring to be a passion for many. We may not know if it is our left or right brain, but the inner child is happy again.

Chapter 4

Mandalas Reducing Anxiety

There was powerful study in *Art Therapy: Journal of The American Art Therapy* that helped prove the value of adult coloring. Written by Nancy A. Curry and Tim Kasser, "Can Coloring Mandalas Reduce Anxiety?" (2005) is a landmark paper outlining the effects of different types of art activities in the reduction of anxiety.

In the study, the authors share that "84 undergraduate students were randomly assigned to color a mandala, to color a plaid form, or to color on a blank piece of paper." Their study found that "anxiety levels declined." It went on to say that these findings show that structured coloring "may induce a meditative state that benefits individuals suffering from anxiety."

This study helped adult coloring become a phenomenon. Many media outlets reported on the benefits of this hobby. The sales of coloring books began to boom. In 2014, there were about one million adult coloring books sold. In 2015, the sales soared close to twelve million copies. It was obvious that these books were catching on.

In recent months, there have been all types of adult coloring books. A few include those with Christian themes, Alice in Wonderland characters, Harry Potter characters, and even ones using expletives. This has led some researchers and art therapists to speak out on this growing hobby. They want to help consumers understand that coloring in a book does not replace traditional psychotherapy. It is also important not to assume coloring is better or more effective than working with a trained art therapist.

Art Therapy Group: Coloring Books Are Great, But . . . by Ernie Smith talks about the change in perception on this topic. Donna Betts, the head of the American Art Therapy Association, has also spoken out, arguing that while "The American Art Therapy Association supports the use of coloring books for pleasure and self-care . . . these uses should not be confused with the delivery of professional art therapy services, during which a client engages with a credentialed art therapist."

The article goes on to quote a Ted.com interview with art therapist Marygrace Berbarian. "I lean toward the fact that there are therapeutic effects, but it is not art therapy. Although art therapy relies on the practice of creating art, it also involves the relationship and witnessing of a trained practitioner."

The American Art Therapy Association delves further into this topic, stressing that

> While the AATA does not discourage the use of coloring books for recreation and self-care, coloring activities must be distinguished from art therapy services provided by a credentialed art therapist. The AATA endeavors to promote accurate information that distinguishes between engaging with coloring for

self-care and accessing art therapy services provided by a credentialed art therapist. We also acknowledge the coloring book trend as an opportunity for the AATA to help educate the public about the evidence-based integrative mental health profession, art therapy.

The association states the need for understanding the difference of at-home coloring and professional art therapy services. They illustrate that art is both rewarding and enjoyable. It may be therapeutic to produce any type of artwork. This "should not be confused with the delivery of professional art therapy services, during which a client engages with a credentialed art therapist."

My training is in social work and for many years I practiced traditional psychotherapy. I know that counseling is a very important tool. You cannot assume that books or anything else can replace working with a licensed mental health professional. It is so important to seek help if you are facing severe issues.

The American Psychological Association has a section of their website called "Psychotherapy Works." They write:

Getting help for depression, anxiety or any other psychological concern is a big step toward feeling better. Drug therapy has become an increasingly popular choice over the past decade, but research shows that psychotherapy is just as helpful—if not more so, in some cases. We want you to know that you have a choice when getting treatment for depression, anxiety or other psychological concerns. Psychotherapy is one of those choices.

So where does this mixed research leave us? There are clearly some positives to adult coloring. It may help to reduce anxiety and act as a stress reliever. It's also clear that the mental health profession wants people to understand that their work is far from simple. They spend years training to understand the connection between art and therapy and how best to help a patient. They have at their disposal a long and varied list of therapeutic tools. While coloring in a coloring book might help, it cannot replace the help offered by a licensed psychologist, social worker, or art therapist.

When facing major problems, you need professional help.

Chapter 5

Relaxing for Improved Health

The fight or flight response is a wonderful description of how our minds and bodies respond to fear. Walter Bradford Cannon was responsible for the pioneering research on this topic. Theodore M. Brown and Elizabeth Fee explored his life in an article in *The American Journal of Public Health*. They describe how Canon was interested in understanding the physiology of emotions. During his studies, he watched how animals handled fear or disturbing situations. The animals had "peristaltic waves in the stomach sometimes ceased abruptly."

They also describe how Cannon found animals responding to strong arousal. Brown and Fee wrote "the sympathetic division of its autonomic nervous system combines with the hormone adrenaline to mobilize the animal for an emergency response of flight or fight." This creates changes in the supply of blood, availability of sugar, and even the body's clotting potential. This is possibly wired into our minds and bodies to help us survive dangerous situations. It would make sense that animals and humans need protection from predators or other life-threatening situations.

Most of us have heard about and experienced the extreme degree of fear and intensity of emotion triggered when we are nervous. Did you know there is research about the exact opposite of fight or flight? Herbert Benson is a doctor from Harvard who coined the term "relaxation response." He wrote the book *The Relaxation Response* (1975) with Miriam Z. Clipper.

The Benson-Henry Institute for Mind Body Medicine is located at Massachusetts General Hospital. What Benson discovered was "The relaxation response is a state of deep rest that changes the short- and long-term physical and emotional responses to stress (e.g., decreases in heart rate, blood pressure, rate of breathing, and muscle tension). Methods to elicit the relaxation response include meditation, mindfulness, progressive muscle relaxation, tai chi, and yoga."

Working with Robert Keith Wallace, Benson observed that meditation reduced metabolism, rate of breathing, heart rate, and brain activity. Through further study, Dr. Benson found that the two basic steps needed to elicit the relaxation response are: placed at the repetition of a sound, word, phrase, prayer, or movement; and the passive setting aside of intruding thoughts and returning to the repetition. This can be done using any number of meditative techniques, such as diaphragmatic breathing, repetitive prayer, qi gong, tai chi, yoga, progressive muscle relaxation, jogging, even knitting.

Benson contends that "60 percent of all visits to health-care providers are related to stress. It causes the 'fight or flight' hormones, epinephrine and norepinephrine, to secrete into the bloodstream. This incites or exacerbates a number of conditions. They include hypertension, headaches, insomnia,

irritable bowel syndrome and chronic low back pain, as well as heart disease, stroke and cancer."

Another recent study goes further in testing the ability of relaxation response techniques to improve health. It shares how yoga, meditation, and prayer impact us. The study, "Relaxation Response and Resiliency Training and Its Effect on Healthcare Resource Utilization" (2015), found that those using these techniques had a healthcare utilization reduction of 43 percent in the first year. It goes on to say that "mind body interventions such as 3RP, have the potential to substantially reduce healthcare utilization at relatively low cost."

Would it be a large leap to say that coloring also helps limit our fight or flight response? Does coloring use what Dr. Benson describes as relaxation response? It may be that the same reduction of stress from yoga and meditation also happens in coloring. I believe future studies will pinpoint that coloring also helps lower cortisol. This may assist our bodies in the damage that stress causes. There are still years of research and knowledge needed to determine the health benefits of adult coloring.

I have devised a few questions to help you understand your emotions. The first five questions are best done before beginning a coloring activity.

1. What is your current level of stress on a 0 to 1,000 basis? 0 would mean no stress at all. 1,000 would be the highest possible level of stress.
 Your stress level number is:

2. This is going to be a free-form list that you make up now off the top of your head. Please write and describe anything you are currently nervous about. It can be anything from simple to complex. The key idea is to accurately express the fears you are having before coloring.

I would describe my current fears as:

3. These are recurring ideas that come up in my life. An example would be wondering who a future love would be, being curious about the success of a project, wondering where you may move to, or any other repetitive idea. The goal is to think deeply about the thoughts you have that come up often. They may not be fears, but ideas that are very important to you. If you are thinking about them often, they may be valuable for you to look at and understand.

I describe my recurring ideas as the following:

4. There are people in my life who cause me stress. It can be a parent, boyfriend, girlfriend, classmate, coworker, boss, or someone you interact with frequently. The goal is to write down their name and a brief reason why they are a source of your stress. An example would be: "My Boss Paul. He always puts me down and doesn't value my work." The hope is that by looking at your thoughts about this person, you will better understand your thinking.

5. In this section you are going to describe your least favorite activities. You may include anything you feel that you

have to do. It may be brushing your teeth, paying bills, talking in public, walking in the rain, or being alone. I want you to understand some of the items you regularly have to do that cause frustration. You may also include a reason you dislike this activity. One example may be "I hate walking my dog. He is always fighting with other dogs and trying to bite people. I also hate cleaning up his poops. It is sometimes loose and smells horrible. It is not even my dog and I do it to satisfy my girlfriend."

I am sorry if those five questions were difficult. It may have brought up some unhappy thoughts and memories. You often have to look at feelings before experiencing change.

The next set of questions is meant to be done right after an adult coloring session. The goal is to just finish and then answer these as openly as possible. It will help you to record your thoughts and gain an insight into your thinking process.

1. I have just completed a session of coloring. There is an overall feeling I am experiencing right now. I first want

to ask your level of calm at this point on a 0 to 1,000 scale. If zero means you are as nervous as possible and 1,000 means totally worry-free, where do you rate?

2. I would describe my emotions during the coloring session today as:

3. The best part of coloring for me is the following:

4. This is a chance to describe the difference before you started coloring and after finishing. You can share how your mind and body have changed. If you forget how you felt before please read the answers to the first five questions. Please place your description below

We can see that monitoring our emotions is a valuable tool. It is easy to do these questions as often as you want. You may find that the answers give you greater understanding. It may also help you figure out if coloring changes your thoughts. I have found that simple shifts in thinking can make positive change. This could be a wonderful way to look at your emotions.

Chapter 6

Depression and Coloring

There is a study on how art therapy helped a group of cancer patients with depression. The study is called "Art Therapy improved depression and influenced fatigue levels in cancer patients on chemotherapy" by Gil Bar-Sela, Lily Atid, and Sara Danos, *and was published* in *Psycho Oncology* (2007). It talks about how those with cancer often are depressed and vulnerable due to severe chemotherapy treatment. The study looked at art therapy and its impact on helping them. They concluded that "Anthroposophical art therapy is worthy of further study in the treatment of cancer patients with depression or fatigue during chemotherapy treatment."

When faced with cancer, our minds change. We live with more fears, stress, and problems. In a time of depression, our cognitive thinking changes. We experience all types of emotions that are different than usual. How do we handle earning less, large scale layoffs, fears for our future, and worries about survival? I began to ponder this topic ever since 2008.

I was working as a therapist in Long Island, New York. I provided counseling to many families, including several

financial workers. It was during this time a patient came in while employed at Lehman Brothers. She was initially in my office wanting to improve her marriage and general thought processes. Within a short time, we hit a crisis. The fear was that Lehman Brothers was in trouble. There was a great amount of panic and concern within her firm and many others.

I asked her if she was worried. She had begun wanting to be a teacher, but found a high-paying job at Lehman Brothers. This woman was so warm and kind to everyone at work. When the collapse began, she described it with passion. Her friends and team were scared. Many had all their financial futures in Lehman Brothers stock and retirement savings. They were fearing the worst and worried about losing it all. I began growing nervous myself.

This woman, however, was charting a different course. She told me her choice was to be optimistic. Each day, she went to work and helped everyone. Her goal was to listen, support, and be warm to everyone she encountered. How would you handle it if your whole company was about to collapse? It was clear her attitude was unique. In the end, our greatest fears became a reality. Lehman Brothers did collapse and the financial crisis began. I was upset like every American who feared for the country's future.

I was amazed at my patient's response. I asked her if she did this for herself. She said no and that she believed it was the right thing to do. She believed that no matter what happens, you should be kind, compassionate, and caring to those you work with. It was hard to see her friends so upset and to no longer have the company. I was worried about her future and the fact that her salary helped support her kids. I prayed for her and hoped something positive would happen.

During the crisis, some of Lehman Brothers' assets had value. The firm Barclays came in and bought some of the remaining parts that could be transferred. The team at Barclays chose to keep a tiny percentage to move with them to the new company. Who did they choose? It was a miracle, but my client survived the storm. She ended up at Barclays and her salary was intact. I learned that sometimes staying calm can change your personal situation. I was so grateful that she was able to make it through this time.

I stopped working with her a long time ago but a few years ago I called to say hello. I learned that she is now a Vice President at JP Morgan Chase. I believe she deserves all the success she has achieved.

I share this story because it led me to find hope in a dark time. I began to see how depression was impacting those I work with. I did talks at many organizations. There were so many who were growing hopeless and hurting from the economic downturn.

In my own life, there have been many projects that failed during the tough economy. I began to feel like Rocky Balboa as each time I had to pick myself up from temporary defeat. Do I keep trying or just throw in the towel and give up? I am not alone and many of us must decide how to move forward even when the times are not ideal. I have read about students with expensive degrees now saddled with debt and few prospects for good-paying jobs. What does it feel like to go to law school and come out with no job? How is it to become a teacher and find out the school boards have no openings? What about joining a start-up to find that they are out of money and laying off everyone?

So where does coloring fall into this? The coloring passion is a way to soothe our hurting souls. Many of us are longing for happier and more joyful times. We remember the simple days of living, loving, and being prosperous. I remember when I had money and $300 could go to a fancy pair of sunglasses. I now use the $300 to pay for a month's worth of groceries at Walmart. I am not the only one struggling to keep up with the real problems that financial failure has handed us.

We color, in part, because our lives are meant to be joyful. Each of us has inherent gifts and abilities. I spoke with a client recently who has a mental illness. A few months ago, she was in a mental hospital. She is now out and trying to come to grips with her life. She used to be an athlete and very social. Each day she writes her lessons about how she has handled her pain. We spoke about turning this into a book to teach elementary, middle school, and college students her lessons. It is wonderful to release our feelings by putting pen to paper. I write many books and have done so for a long time. This is my therapy and the way I process many of my problems. I wrote a book about mental illness and addiction when my own brother died of a heroin overdose. I shared about being locked in a mental hospital because the raw emotions needed an outlet and way to heal. I have been to therapy for much of my life. There is another part of me that needs a positive way to express the trials and tribulations in life.

Do you need coloring to help you? Does the simple act of sitting quietly help you handle the myriad of issues you experience? I know that art is one of the most optimistic parts of our lives. When we are focused on creation the rest

of the noise grows silent. We are engaged in the moment and not focused on fears. There are other choices, but do they help in the same way?

I know many are watching the United States Presidential election with fervor. There are some who love Hillary Clinton and others who loathe her. Many feel the same intensity about Donald Trump and his candidacy. Whatever way you lean, is watching the news healthy? I notice many news outlets playing the daily fights and dramas between the candidates. There are some who find this exciting and thrilling. Do you walk away feeling better after watching this coverage?

When I watch, I often feel sad. On one side they talk how terrible the candidate is. The other channel speaks about how bad the other one is. It leaves me feeling that no matter who wins, half of us will be angry and frustrated. I also don't think the coverage focuses on how to create hope. A great amount of the discussion is about how bad the other one is. Do we gain from fighting with each other and trying to make someone else look bad?

Dealing with depression is hard enough. When you are depressed in a time of depression, it is far worse. The part of depression that is challenging is when the pain you feel is accurate. When the whole world is in trouble our human minds are scared. I have two children and worry about their future. I read about the depression in the 1920s and know it can become even worse than it is now. I want real answers and solutions but I don't have them. I wonder if anyone does. So what are we to do during these complicated times? I stopped drinking because addiction is the wrong way to deal with depression. It may be that the outlets we need to handle depression are simple. They may include writing, drawing,

painting, working out, dancing, listening to music, and having fun. Coloring falls into this category of helpful ways to process our pain. My brother found heroin to deal with his struggles. It killed him and his death showed me how the wrong choice can end in tragedy. I've yet to meet anyone overdosing on coloring. I encourage you to pick up your colored pencils. We may deal with depression with a simple coloring book that we can afford. It may help us color our way to a brighter future. If life becomes harder, we will need ways to handle these feelings. I am encouraging my family and those I work with to use coloring as a healthy tool for depression.

Chapter 7

Brain Health and Our Choices

We are in a time of easy access to information. The computers and phones we own make it possible to access more of everything. Does this large amount of information help or harm our brain health? There is a massive amount of knowledge we can find online that couldn't easily be accessed several years ago.

Dr. Sandra Bond Champion is a cognitive neuroscientist and the Chief Director of the Center for Brain Health at the University of Texas at Dallas. She has worked for over thirty years studying the brain and its uses. In 2014, she authored the study "Enhancement of cognitive and neural functions through complex reasoning training: evidence from normal and clinical populations."

This study showed that our brains benefit from focusing on one topic at a time. We can better use our brains by not attempting to multi-task. Dr. Champion also noted ". . . it was **not** learning new information that engaged widespread brain networks and elevated cognitive performance, but rather actually deeper processing of information and

using that information in new ways that augmented brain performance."

Dr. Champion has continued to help us understand the way our minds work. Her advice is to start single-tasking. Essentially, our brains were not made to do multiple tasks at once. It's why so much of what keeps us alive is done automatically. When we are doing two things at once, in reality we are rapidly switching from one task to another so that it seems we are multi-tasking. This has actual detrimental effects because it activates stress hormones that are harmful to our bodies. Dr. Champion believes that focusing our full attention on one thing increases our speed, accuracy, and innovation. The coloring that we enjoy is a single task. To truly immerse ourselves in it, coloring done without television, internet surfing, or talking on the phone will create a richer, more focused moment. I recently did an experiment on myself to better identify the effects of an immersive, single task.

I live in a hectic household with two young children. My daughter is seven years old and filled with energy. My son, Ryan, is two years old and also is loud and fun. They have friends over often and my home is a large play area. During one of these days, I began to feel stressed. There were five kids at my home with their mother and my wife. This was the perfect opportunity to document the changes I felt. In the beginning I was slightly nervous and on edge. The loud noise of several children playing was distracting. I was hoping to write and found it hard to concentrate with the noise and sounds.

I took a coloring book and went into a room alone. I closed the door and could not hear the children playing. I began to shift from a nervous feeling to one of deep focus. I

watched how my mind began focusing on the color crayon I was using. I was attempting to create a new and interesting coloring pattern. I began to feel at peace while my mind was only working on the task at hand. There were no noisy children, anxiety, or frustration.

I did this for about thirty minutes. I noticed my back became more relaxed. My mind was no longer racing and throwing around fearful thoughts. I sensed more joy and gratitude for this thirty-minute break from the realities of parenting. I even found when I came back to join the group I was calmer. I could see the other parent and my wife were nervous. They had been in a loud environment with kids running around. I felt calmer, more in control, and ready to jump in and help.

I gave my wife and the other mother a break from their duties. I began to watch the kids. I was relaxed enough to play with them and we made up some new games. What I found was that the coloring worked as a great tool to help me handle the stress. It also broke up the day and helped my thinking change. I began to see that this could be done almost anywhere.

I was recently on a family vacation and tried the same experiment. I took a thirty-minute break from parenting to color. Once again it helped me to relax and stay on a single task. I realize that many other parents of young children could also use a coloring break. I began to see that even within work settings this could be an advantage. No doubt there are offices filled with stress. I imagine a lot of you reading this book know exactly what that's like. Now imagine if you were able to take a break, mute your phone, ignore your email, and simply color? Would you be more stressed or less when you clocked back in? I argue, and the science

is growing every day that supports this, that you'd be calmer and better equipped to tackle whatever comes next. That, in turn, benefits both you, the employee, and the company.

Large start-up companies have begun introducing similar ideas. We've all seen the images of ping pong tables, napping pods, and even a bowling alley in a workplace. The idea is that they want the workers to feel good and not burn out. They find these extra activities help to break up the pressure and stress within a business. Is it likely these businesses would have such things if they didn't also help the bottom line? Happy workers are inevitably better workers. It may be that more of us should embrace ways to make simple changes each day to reap the same rewards.

Years ago I was working with the owner of a small company. He had about eight employees and came in for a session. He was so stressed that his health was failing. The client opened up that he was under massive pressure to keep the business going. His choice was to put this pressure on himself and his team. They were all burning out and the goal of success was becoming more remote. We talked about this and how his behavior was harming everyone.

My suggestion was to help change his own thinking. I shared that happier leaders make better bosses. We are rarely inspired by a leader that yells, is aggressive, and makes us feel badly. He began to understand that there are new ways of helping. He knew he wanted his team to help him grow sales, but his approach had not been getting the desired result.

The next week, they started a meeting to help this initiative. Each member was given a notebook. He told them the truth. If sales are not improved in the next six months, he

may have to close the business. He was open about his goal to keep going and to grow. He also apologized and said he was sorry for his angry attitude.

The team then spent thirty minutes sitting alone writing in their notebooks and coming up with ideas to improve sales. At the end of the thirty minutes, each worker had ten minutes to share their ideas. The concepts were all different, unique, and inspiring. Every team member felt valued and that they were contributing to positive changes.

They would go on to work better together. The whole staff was now on a mission to find success. They began to understand their boss and why he was so nervous. It was hard to admit that the business was in trouble, but the truth set him free. The team started to see that they were all in this together. They were now all willing to work and try to change the issues vital for their company's success.

In our lives, coloring is a piece of the puzzle. Many of us face struggles and problems. It may be a parent trying to juggle it all. There are others with work pressure battling a hard economy. For some, it is the feeling of isolation and loneliness that is very difficult to handle. I don't have all the answers and I know it is worthwhile to keep on looking. In my own life, coloring has been a positive passion. I can sit alone and create something beautiful. It is simple, affordable, and can be done almost anywhere. In a time of pain, we need tools to help change. The most basic art of coloring is a powerful force for happiness. I never thought I would be almost forty and enjoying coloring books. I am not alone in admitting that it helps and I am open to using all the tools available.

Chapter 8

Releasing Problems

Is it in our nature as humans to want to escape our prob-
lems? I began to wonder this when my brother died of a
heroin overdose. It hurt my parents so deeply for them to
lose their son and to feel the sorrow of his death. I started to
feel in my own life that I wished I could take away the emo-
tions and anger about his death. This is when I chose to face
my feelings and not let addictions temporarily alleviate the
hurt inside.

Over the years, I have helped many going through dif-
ficult struggles. I was working with a client named Yolanda.
She was in her early twenties and facing great pressure. She
openly shared about trying to handle her stressful job in
finance, worrying about her future, and trying to find her-
self. Yolanda also felt real uncertainty if she would ever get
married and have children.

When she came in for her session, she seemed discon-
nected. We spoke for a few minutes and she started to open
up. I asked her what she did when feeling nervous and upset.
She said, "I am embarrassed to admit it. I smoke marijuana,

drink vodka, and have wine. I try hard to calm down." We then began to consider if this was helping her. She said, "I feel good that night and my feelings go away. The next day I feel like shit. I am tired, edgy, and can't work."

We spoke at depth and she continued, "I am starting to drink each morning to get by. My dad had alcoholism and died at fifty-five." This led to her sharing about her childhood. Yolanda told me her dad was so addicted that each night he would scream and mentally hurt her whole family.

Yolanda's biggest fear was repeating the pattern that her dad established. She didn't know what to do, which is how she ended up coming in for help. I began to share that it is hard to face problems. Many of us look for ways to soothe the pain and frustrations we feel. I then told her that there are other tools to deal with stress. I spoke of a deep breathing technique. I shared how taking three long and deep breaths are a great way to let out stress. I also spoke of doing workouts and making the gym a healthy habit. My final tip was to find a creative outlet for her feelings.

Yolanda opened up that she loves to make art. The only problem is she isn't the best artist. I told her that coloring, doing freestyle drawing, and painting may be a great resource. She started by creating space in her living room. Each night, she came home from work and gave herself one hour of time. She filled up a glass with ice water and began to engage in art. She would color, paint, and draw. When she was angry, she could use dark colors and even write mean things about those upsetting her.

She told me this completely changed her life. Yolanda stopped using drinking as her coping mechanism. She found that art was a way to let out her feelings and open up her

mind. Within a few months, she made dramatic changes. She began working out three to four days a week. Her evenings and weekends now include doing art, hiking, and taking a dance class. She met some new friends and even found a great boyfriend. Yolanda credits her different choices for helping her develop better patterns. Her goal of not repeating her dad's life of addiction may be achieved. It took her being open about where she was mentally and facing her fears. I give her so much credit for being honest and sharing her deepest feelings. It became easier when she was willing to admit and face the problems.

Why is coloring a tool for facing issues? In a world filled with so much technology, many of us yearn for simple ways to handle stress. This is why yoga, meditation, drawing, and coloring are gaining our attention. We understand that finding healthy outlets is one of the best ways to handle stress. Many of us make remarkable improvements when we let go of our fears and find a tool to help us.

Another patient I worked with, Kevin, came to me feeling that it is hard to handle his life. Kevin was deeply in debt and owed over $30,000 on his credit cards. He has a job, but it does not provide enough to allow him to afford his responsibilities. He admitted that he is becoming depressed.

"It feels like I'm a rat in a cage. I keep running and trying to get ahead but I end up chasing my tail." He admitted how hard it is and that he secretly feels worthless. I began to help him focus on some positives. Kevin is working a full-time job and doing it to the best of his ability. Even though he has some debt, Kevin pays his rent and bills on time. He has his own apartment, food, and the basic necessities.

We started to look at his finances and to see how he could adjust. One step was to create a budget and figure out how to lower his expenses. Kevin began to see that eating out three nights a week cost him over $500 a month. He also admitted that he bought many pairs of sneakers. Kevin said that it is great to have nice shoes, but he was wasting about $200 a month on them.

It took time, but Kevin began to pay off his debt. He also realized that he needs to spend below what he makes. It wasn't fun but he began to keep track of all his expenses. He made hard choices but it was leading him towards a better way of living.

One day, we began to speak about outlets. Kevin loves basketball and wanted to attend the games. He knew that the tickets cost so much that it would not be possible. Kevin could watch on television and save a large amount of money. He then opened up about needing a tool for stress. He came upon the idea of getting some adult coloring books.

The first week was a remarkable response. Kevin said that coloring helped him let go of his anger and stress. He would come home from work and take out his markers. Kevin would draw and color in the designs. This became a hobby that he enjoyed. He would buy one book a month, and for about $10 he had a fun activity. Kevin took the subway to work and would often color during the commutes. He used to be so bored and get depressed during the hour long trip. He now has a peaceful way to handle his feelings.

Your coloring hobby may actually be helping to improve your life. It is possible to have fun and heal at the same time. These days, many are facing all types of adversities. I have learned that finding tools to deal with our emotions may

lead to a better path. When you embrace adult coloring, you are providing a simple way to express yourself. This may allow you to handle your problems and press forward. During the times you feel lost, a simple outlet may help you embrace the uncertainty.

Chapter 9

Disconnecting from Technology

There are many benefits to using technology. One of the most obvious and useful is access to massive amounts of information. You can also keep connected to family and friends through Facebook, Skype, and many other social platforms. I often find my way to new locations using the awesome map on my cell phone. These are just a few reasons why so many of us embrace modern tools.

I have found in my work and life that technology has its drawbacks. This includes us having tons of Facebook friends but not as many in-person interactions. There have been many parents who share that their child sits home and alone playing on their computer. They are not willing to go into the real world and make personal connections. It often leads to a greater issue of social isolation and loneliness.

During some of my educational talks, the parents in attendance spoke of this issue. What is a mom or dad to do? How can someone change these habits? Is our society moving towards one only filled with technology and less face-to-face experiences? I also began to wonder how this is part of

the coloring phenomenon that many of us enjoy. It seems so basic to buy a book to color in when we have millions of apps, games, and other technologies for free. Is it possible some of us are searching for a simpler way of life? Do we miss the old days of sitting together in the same place versus texting and other modern marvels?

I have felt the emotion of sitting peacefully in a room and listening intently to my coaching client. There are no phones on and it is quiet with almost no distractions. In those sessions, I hear everything and sense deeply what my clients are expressing. I can only say that the power of two people talking may be greater than anything else we experience. I have been blessed to help people work through divorce, addiction, depression, losing a parent, facing homelessness, and even having a terminal diagnosis.

It is not easy, but when we come together we can actually change our thought processes. We may know some of the answers already, but hearing it from someone who cares may make all the difference. I still work with a mentor because I know I don't hold all the answers. When we are put together with others, it may lead to the solutions we seek. I think this is how coloring can possibly lead us to a temporary disconnection from technology.

I am Jewish and the more religious of my faith celebrate a holiday called Shabbat. This includes turning off all electricity, phones, and power on Friday evening. Many will spend quality time with their family and not focus on work responsibilities. I was listening to a discussion with famous entrepreneur Ronald Perelman who created Revlon. He began many years ago taking this time to be quiet and stop working. He shared that this has helped him to be better

balanced and to handle the large amount of effort it takes to run his business.

I know he is not the only one to benefit from disconnecting from technology. What would it take for you to have a few hours without your phone, television, or computer? In that time, you may do some coloring or other creative project. It also might mean talking to those you love in person and actually spending time together. If you are married, you may talk with your spouse about how they are doing. For those with kids, you may ask about their adventures in life.

We all secretly have a need to be loved. The virtual friendships online are not the same as face-to-face experiences. I do know that sometimes we are limited in seeing certain people. If your family lives far away, it is not easy to fly and be with them. If your loved one travels for work or is in the military, it can be a battle to talk face-to-face. In those situations, Skype or other tools may be the best option. This still doesn't mean we have to be all alone, even if we are far from those we love.

I have a strange situation that has happened dozens of times. I have been doing therapy and recently coaching with all types of people. There are some who are extremely successful in their careers. Many openly admit that they do not have many friends. A few say that as they become older, their close friends no longer live near them. They admit to being lonely and long for a way to have human connections.

This is so common and it has even happened in my own life. I have many friends from all over, but few in my new town. I have moved often over the last few years and it takes me time to develop new relationships. I now have three friends that are in my area and it has taken time and effort

to cultivate these relationships. The tips I share with others I often use in my own life.

A few steps that help are to find a group that is open to new members. I am signed up for Meetup.com, which lists many social functions that appeal to a variety of interests. They have groups for adult coloring, dancing, writing, nature walks, photography, singles, parenting, and so many other interests. You can join for free and participate in many different groups. I have done this myself and many are there looking to meet new people.

I also have worked with those who have been through something really traumatic. They may be scared to go and be in front of others. In my work with those with mental illness, many feel fear joining a Meetup.com group. I then encourage them to learn about the National Alliance on Mental Illness or the Depression and Bipolar Support Alliance. They both offer free local groups for anyone impacted by mental illness. You can find their information at nami.org and Dbsalliance.org.

There are also patients I encounter whose addiction is a major source of their pain. I share how Alcoholics Anonymous and Narcotics Anonymous are always open and willing to help. There are many other types of support groups located in some communities. A few I have heard of include ones for spouses in the Army, those who lost a loved one recently, parents with children with special needs, and learning to support a loved one with cancer.

I think it is sometimes frightening to join a group. I have run groups for actors, those with bipolar disorder, writing groups, and even a support group for families facing brain cancer. I watch as some enter for the first time and don't

know what to expect. Will they be judged? Will it be scary? Are they a right fit for the group? I do my best to help them relax and to make everyone feel comfortable.

The option of not joining something means you are accepting being alone. It is wonderful to be with yourself, but sometimes we need other human beings. When you are willing to put yourself out there you may make a new best friend. It is possible you will be a friend to someone who needs an amigo just like you. We are all together when we admit that loneliness is not the best option.

I have spoken with some who have their reasons for staying lost in technology. They may have been hurt before trying to socialize. A few admit they were bullied and called horrible names in school. They still carry the wounds from trying to assimilate but being rejected. Many are so sad about this that they give up on trying to meet others. I have seen some who love their computer instead of finding actual love. They made the hard decision to give up on humans and protect themselves from any more hurt.

I often tell parents they cannot force their child to reenter the world. I spoke with a mom recently who told me she doesn't know what to do. Her son sits alone at home and doesn't care. He is in his mid-twenties and she doesn't know how to help him. I offered to call him but he wouldn't allow it. The mom is frustrated and there are no easy answers. I told her I pray that one day he wakes up and realizes that the world needs him in it. There is a place and purpose for all of us.

I don't know your beliefs about the value of technology. In my youth, it was not common to have a cell phone or computer. I remember girls laughing at me when I had a cell

phone. They would snipe, "Why don't you use a pay phone like everyone else?" I bet they now have a cell phone themselves and it is a major part of their lives. It seems technology is part of almost all of our modern experience. I leave this chapter with an experiment that you may be up to trying.

Take five hours and refrain from using any type of technology. This means no phone, computer, radio, car, or television. You may speak with those near you, or if alone go into a natural setting. It may be a good time to do some adult coloring and make a healthy snack. I want to ask you during these five hours what you are feeling. Do you enjoy letting go of these tools? Is it hard to sit without checking your texts or emails? Did you end up actually enjoying yourself without all the modern toys?

I am going to give you some room to share your thoughts at the end of the five hours. Please be open about your responses and share what it felt like.

When I shut off the technology I felt:

The best part of having a break from technology was:

I would describe my emotions during these five hours as:

I would pick another day to let go of technology because it helped me to:

Coloring makes me feel:

I think the therapy value of coloring is:

I learned from this experiment the following things:

Chapter 10

A Deeper Look at Feelings

I know that much of our connection to art is the expression of pain put into the creation of each work. I wanted to explore how coloring can help us look deeper into our emotions. I find that often we face so much that it feels hard to open up. We may choose to not let out the massive amounts of stress and pressure we face. Do we really have all the answers to solve our problems? Is the economy we are in going to magically fix itself? Are we victims of our times or do we have the power to change?

This struck me deeply over the last several years. There has been so much struggle that it sometimes feels hard to continue.

I was listening to an interesting talk by Abraham Hicks. If you have never heard of this, it is going to sound kind of strange. Esther Hicks and her husband have authored many books. According to Esther, the books come "translated from a group of non-physical entities called Abraham." It is as though this entity provides the answers and knowledge many are seeking. When I first learned about this, I was

confused. Does someone hearing this kind of voice have a valuable message to share? Is it going to be weird or could I actually learn from the teachings?

I began to watch some YouTube videos where people would ask Esther questions with Abraham responding through her. A gentleman was on the microphone saying how bad things are in the world. He used war, starvation, murder, depression, and so much else to prove that our times are terrible. Then, he asked if there is any hope for him even though so many atrocities are occurring now.

The response was that the man was correct. There are many horrible things happening in our world. It is still our own perception of life that counts. We may find happiness, joy, success, and achievement, even in the worst times. On the opposite side, there are some starving or homeless even when the economy is booming. The overall idea is that you must decide to create the life you want despite outside circumstances. This may include being happy even if you have less money than you desire.

This hit me hard. Are they right? Is it up to me to choose how I look at my life? Should I forget my failures and focus on gratitude? I then started to think that everything has a positive or negative. I sold a book on depression that will be out in 2017. In my mind, I envisioned many publishers wanting the book and an advance of close to $100,000. It turned out at the time only one publisher was interested. Their advance was much, much less than my dreamed-of big payday. This sure wasn't what I hoped for. I had spent three years working on a book and the offer meant I was paid, well, let's just say not a lot. So how do I look at this? Is it a failure, or did I succeed?

My agent and I spoke and she said she would understand if I turned down the offer. Her commission would be very small, too, though she worked countless hours closing the deal. I then thought it through. I did get a book deal, which is a success. The book could come out and be a bestseller. I would be entitled to royalties and they could potentially equal millions of dollars. I also may reach someone who is depressed and the writing may make a difference in their life. Do we really gain what we want when we work towards a goal? Is there happiness that comes from enjoying the journey rather than standing in the end zone?

I remember hearing about Deion Sanders. He had played baseball and football professionally. One of his dreams was to become a Super Bowl Champion. It had been a desire he held for a large part of his life. He won the Super Bowl with the San Francisco 49ers. It was a moment he pictured forever. Deion admitted that even though it was thrilling, it wasn't as exciting as he hoped. It is common to have a large desire and then to feel less than happy when we achieve the success.

It is true that we need ways to handle each day of our life. This may mean finding sources of fun that are lights in our lives. I know coloring can be a simple, creative tool to deal with ups and downs. We may take time daily to relax, relieve stress, and have joy. This allows us to feel happier and to remember that this is a long journey.

I find that expression is a big part of our feelings. I was just called by someone who spent twenty minutes talking about his life. He opened up about facing a mental illness and the long road it has taken him to recover. He shared how hard it has been to face other people and to be open

about his condition. He also took time to share his views on bipolar disorder and how he thinks he can make changes to help others. I encouraged him to share his knowledge and to be open. I think just letting him talk was powerful. He admitted there was a time last year when he was alone for five straight months. I think him connecting with others is important and I was happy to let him open up. I wasn't sure if I helped him, but at least I was willing to listen. Sometimes, we need to be heard and to let out our feelings.

I remember during my rap therapy project interviewing an artist named Doug E. Fresh. He said, "You have to let out what you feel. Writing, playing an instrument, music, it's about what you know and expressing it." These words are so true. We all have a need to open up and release what we have inside. It is possible to be free when we no longer hold back our creativity. What are some of the deepest emotions you hold inside? Are you often fearful, nervous, or confused? Do you sometimes search for answers, but still feel uncertain? I am proud to admit that you are not alone. I too wonder about my life and the path I am on. I am brave enough to admit that I don't have all the answers. It is freeing to be able to say sometimes you do not know what is next. This takes away the pressure of always being confident and pretending to know it all.

I used to act so confidently as a kid. I pretended that I knew where I was going. I learned that I was sick with a mental illness and my life shifted. I went from thinking I knew everything to being locked in a mental ward. This journey helped me to understand that I am just like everyone else. I am searching for meaning to many of life's great questions. I am trying to develop, but face roadblocks all

the time. I pursue my dreams not knowing if they are going to materialize or if I am just wasting my time. Maybe none of it is worthless. The problems often lead to deeper thinking, and eventual change. I have found that failing makes us have the ability to try something new. It may mean that being forced to shift through issues actually helps us develop higher knowledge. We may end up more alive by being stopped from having our own way. It is humbling and hopeful at the same time. On the hardest days taking an hour to color may just help us make it through.

Chapter 11

A Substitute for Addictions

Should I grab a beer or drink a glass of water? Is it better to have a cigarette or go to the gym? The choices we make have the power to open ourselves up to healing or hurt our future. I have come to the realization that all of us have weaknesses. My brother started with drinking alcohol and smoking marijuana. He reasoned these are "no big deal" and he was having fun.

It was only years later that he grew to use Molly, opiates, and eventually heroin. I am sure in his heart he knew using heroin was severe. I know he probably never told his family because he was embarrassed at how deep his addiction had grown. When he died at age twenty-seven, he left us all broken-hearted. I had lost my only brother and his passing set me on a new path.

I stopped drinking alcohol and began watching how hard addictions are. I would regularly want a drink, feel embarrassed in front of others consuming it, and was confused. Even when these feelings passed, I would be tempted to make other poor choices. They included gambling and

eating poorly. I would be with my kids at McDonalds when I was tempted to enjoy a supersized meal. I knew the calories would be too many, but my mind would tell me to eat it.

I started to search for other ways to overcome the weaknesses we all have. I began to connect with religion and would often listen to uplifting messages. I will admit that optimism and faith were substitutes for sadness, addictions, and hopelessness. I started to think that this could help me move past my pain. I could also learn other ways of living.

This new concept made me think. I began to deeply analyze my life. I accepted that each day there was opposition to staying strong. I would battle to keep a good attitude and avoid poor choices.

I remembered how many clients also opened up about their temptations. I remember the wife who was scared she was going to cheat on her husband. There was a young man who worked hard and then bought cocaine every weekend secretly in a hotel. I met the woman who lived as a mistress to a married man because he paid for her living. I heard the boss who secretly drank vodka every morning and it caused him to lose his business.

I believe you can substitute poor choices with healthier ones. Each time you grow negative, you correct yourself with a positive thought. A person who is lazy pushes past this and begins to do daily workouts. The alcoholic stops drinking daily and instead goes to an Alcoholics Anonymous meeting. There are countless ways to change how you live. I used to smoke cigarettes whenever I was bored or frustrated. I was working with a client that shared a different way to handle this issue.

Peter began smoking at age eleven. He grew up in New Jersey about one hour outside of Manhattan. Peter met

some kids in school that were considered cool. They gave him a cigarette and told him to try it. He hated the smell and smoke at first. He didn't want to seem weird so he kept smoking. When I met him, he was twenty-six. Peter smoked two packs each day.

He was starting to feel the heaviness from his habit. He was often wheezing, sometimes coughing up blood, and desperate for nicotine. Peter was sick of this and we began to work on it. It began with him opening up about his life. Peter talked about his loneliness as a child and feeling desperate for friends. His mom and dad rarely put effort into his life. Peter was often left alone and always playing in the neighborhood.

Peter also felt that he didn't have much of a future. He went to high school, but barely graduated. Peter was often out partying and didn't care about studying. When he graduated, he thought college was a waste of time. He would start working, but he was always struggling. He became a worker at a 7-Eleven. The hours were long and the pay was low. It was all he knew how to do to survive.

I could understand that Peter was upset. He had obstacles and couldn't see a way out. Peter began to explore his future. One idea was that Peter is great at fixing different objects. I asked if he would ever consider going to a technical school. He thought it was a smart idea and began to look into it. He began attending a technical college to learn to be an electrician.

This put him on a path to making a living that paid more and would be better for the long term. Peter also wanted to stop smoking. We started to talk about what else he could do instead. I told Peter about coloring and he laughed. He

said, "You mean I should color with crayons like a little kid?" I asked if he thought children have fun doing it. He said, "I used to love it at seven, but I'm a grown man." We continued and then he said he would try it.

It was not long before he brought a coloring book wherever he went. He was still smoking but about half as much as he did before. Peter wasn't ready to quit, but his goal was in six months to get a nicotine patch and stop completely. Peter wasn't able to continue with me but I believe he learned better ways to handle his life. He is an example of how you can change your habits and patterns.

It may mean you have to look at your own weaknesses. You may have to seek support if they are consuming much of your life. This will help you to understand where the pain comes from. You may have the boldness to try different ways of dealing with impulsiveness. I know it is better to color than to drink, smoke, gamble, or eat poorly. You can spend a few dollars on a book that will give you countless hours of fun and relaxation. How much better would we be if we colored rather than let destructive behavior rule our lives?

Chapter 12

The Meaning of Colors

We see colors around us all the time. How often do we stop to describe how each color impacts our thinking? When we see the bright red of a stop sign, does it cause us to slow down? Are the neon signs at some fast food restaurants calling us to forget our diets and eat something delicious?

In the book, *Your True Colors: A Practical Guide to Color Psychology*, there is a wonderful look at how colors impact us. The author Catherine Shovlin writes about how important these colors are in our lives. She says, "Color impacts our mood, our well-being, our energy levels, and our appetites. In every environment, in any outfit, under any source of light we are reacting to color cues whether we realize it or not."

The book by Shovlin also shares how colors played a role in our evolution. She shares that, "Color has had an important role to play in our survival. For example, we instinctively shy away from yellow and black stripes—nature's way of saying watch out." It may be that we are genetically wired and

programmed to have different responses to certain colors. It may help us be cautious during certain situations and excited for others. Is this why we pass a blinking slot machine and want to risk our money for a chance of a large jackpot?

Even though the psychology of colors is relatively new, there are suggestions that these ideas have long permeated our minds. In the article "Color Therapy and Healing: An Introduction" from ArtTherapyBlog.com, they provide insights into the history of colors' meaning. They write, "It's no mystery that the sun and its source of light (or lack thereof), can have a profound effect on us. Thousands of years ago, some countries began exploring color and its healing capabilities. Egypt, Greece, and China are known for their forays into color healing and therapy." They go on to focus on a few examples of how history is filled with interesting uses of colors. They describe painting rooms that had specific colors with the goal of helping alleviate certain physical ailments. There were also healing rooms that had colorful crystals that deal with changing the rays of the sun.

There is no precise meaning of what each color represents to us. We may each respond to a color differently depending on our age, background, and even where we live. My goal is to take a look at how colors may possibly be understood. I would be wrong to state that the exact details are 100 percent proven science. It seems there are still years of research needed to correctly understand exactly how the use of each color impacts our perceptions.

I am going to share my perception of colors. This is meant to be general and your own response to a certain color may be different.

White: I view white as a light and cool color. It is one that we hope to use when wanting changes. It is often associated with angels, God, and other visions of heaven.

Yellow: I find yellow to be feminine and attractive. We use it to create or color the sun, flowers, or other beautiful objects. Yellow is soothing, calm, and helps us feel relaxed.

Red: Red has a strength and power. It may symbolize blood, war, or death. It can often be used to color something that is strong and creates changes.

Blue: I used to consider blue to be my favorite color. I find it helps us deal with sadness or confusion. It also appears to be a great color for inspiring our imagination. A few items that are blue include Bart Simpson, certain planets, and the sky. I find blue to be attractive and especially enjoy the shade of turquoise.

Green: This color symbolizes wealth and material objects. It is often used when drawing money or other material items. It can also feel calming when used to draw grass, trees, or other nature. It has a strong and masculine feel to it but can be used in many types of drawings.

Purple: This is a strong and feminine color. It is often used to create pictures of flowers that strike our minds. It is a wonderful color that grabs our attention.

There are other examples of how colors have certain meanings. Color Wheel Pro is a software program to create

color schemes and use them on real world examples. On their website they say, "Red is the color of fire and blood, so it is associated with energy, war, danger, strength, power, determination, as well as passion, desire, and love." They go on to describe red as an emotional color. They believe "It enhances human metabolism, increases respiration rate, and raises blood pressure." They also discuss its use in stop signs, fire engines, and other important items.

Jennifer Bourn writes in *Color Meaning: Meaning of the Color Yellow,* "Yellow, the color of sunshine, hope, and happiness, has conflicting associations." She shares that yellow often stands for optimism, happiness, clarity, and freshness. There is another side to yellow that often represents deceit or cowardice. Bourn talks about studies showing that yellow increases mental activity. She goes on to explain that bright yellow is able to grab our attention. She says "This is why school buses, taxi cabs, and traffic signs are painted yellow and black."

The website colormatters.com shares in an article the meaning of blue. They write how blue is the favorite color for many people. "It's nature's color for water and sky, but is rarely found in fruits and vegetables. Today, blue is embraced as the color of heaven and authority, denim jeans and corporate logos."

The color black is often thought of when someone passes away. We also see it as a stylish color worn to help us look thin or cool. Colorpsychology.org gives their interpretation of black. They say that "Black is a color to be used with caution, as its positive aspects often are closely linked to its negative aspects. Black suggests power, elegance and style, but also intimidation, aloofness and limited emotion."

Kate Smith writes about green in her article "All About the Color Green." She says, "It's the symbol of prosperity, freshness, and progress." Kate also talks about how we associate green with wealth and vitality. Green is a strong color often used to illustrate passion.

I want to give you an opportunity to examine your own feelings about colors. The goal is to help you identify your own thoughts and emotions. I ask you to take out a set of crayons or markers. You are going to do some coloring with each color. While you use one color at a time, think of the emotions you are feeling while coloring. There is no right or wrong ideas. This will hopefully allow you to become aware of how colors impact your psyche.

While using the color white I feel:

While using the color blue I feel:

While using the color yellow I feel:

While using the color red I feel:

While using the color orange I feel:

While using the color black I feel:

While using the color green I feel:

You may also view your environment. What do you see when driving or walking around when it comes to colors? Do you feel calm and peaceful looking at nature due the colors of trees, plants, and flowers? I am hoping you become more aware of the patterns of colors and how they change our thinking. You may end by helping yourself to understand why certain colors evoke changes in our psyche. I find myself nervous with the bright lights of a flashing fire engine. Do the colors we see help us avoid danger or psychologically

entice us to have a certain response? This is why many businesses use color psychology. Many consumers are rarely conscious of how slight color variations may tempt us to shop, eat, and buy particular items.

Chapter 13

Finding Light in Creativity

There is an inner light that each of us are born with. As a child, we openly laugh, smile, and are free. Many of us grow cold towards our lives and begin to withdraw. This happens from being hurt by other children or having inner turmoil. Does feeling upset actually help us to experience our best potential?

I used to live much of my life in fear. I was focusing on pain, problems, and keeping away from the light. I found that this made almost everything difficult and stopped me from being joyful. I began a spiritual quest to go to the bright side. This included finding positive influences, studying optimism, and spending time in nature. As I continue on this journey, I consider every step to be well worth the effort.

For many years, I have created educational videos on YouTube. They include talking about depression, bipolar disorder, addiction, nature, optimism, and many topics. At this point, I have created close to 600 videos! I find it to be one of my favorite ways to express my thoughts. I also believe that

many are watching YouTube instead of traditional media outlets. My goal is to provide education about important topics to anyone who may benefit.

I received an email from a person who watched one of my videos. He basically said they are a waste of time and have no value. This week money has been tight and I have started to feel insecure. When I heard this comment my ego took a big hit. I thought to myself, "Maybe he is right. Am I a loser? Did I waste my time making so many videos?" I went down this path for a few minutes. I started to question whether my self-expression is a positive or negative activity. I scanned the videos and chose to watch a few.

One video was titled "Portrait of a Heroin User." In this clip, I openly talked about my brother. I shared how he was a warm, friendly, and adventurous person. He started drinking and smoking pot. This progressed to Molly and eventually heroin. I cried in the video, talking about the night he died from a heroin overdose. The video was created by me just months after he died. I was still in such pain that I could feel the raw emotions on my face. I was hurting but I was trying to teach and reach someone else. Are they a waste like the critic said, or are they serving a higher purpose?

I began to scan the comments from this video. It has had about 500 viewers. One comment shared that they lost their brother also at age twenty-seven to a heroin overdose. They thanked me for the honesty and said it helped them deal with their own pain. Another viewer said how they started with simple addictions that eventually led to heroin usage. They were open about how difficult and challenging it has been to recover. The next comment also shared about how

bad the heroin epidemic is for our world. These comments helped me to look at my creativity.

I would not let one person putting me down stop me from moving forward. I may not be approved by him, but my faith gives me the courage to keep going. I also know that sharing my lessons has helped me learn and look deeply at my own life. I don't have to be loved by everyone to know I have a positive self-worth. I am learning that one angry viewer doesn't deserve to stop me from trying to help teach. They may have their own issues that are causing them to vent their frustrations on my work. I hope they only find happiness and joy in whatever they do. I also chose not to reply and not feed on negativity.

It has taken a long time to mature to this level. When I was younger, one mean comment could send me in a tailspin. I could feel worthless with just a few mean words. I used to want everyone to like me. I now know there will always be some who don't like you. It is okay, and sometimes the harshest critics help us make the most emotional growth. I also cannot name one person in history that has been universally loved. When you have the courage to share yourself publicly, many will want to put their own opinions into what you do. You have to decide if you are willing to shake off the put-downs and keep moving forward.

I have learned that creativity is a unique animal. It comes to us in different ways. There are some artists who drink or get high to make their art. In other cases, some are touched with faith and believe the divine comes through their creation. I know of countless artists who faced immense pain and channeled this into their art. I want to share a powerful example about a musician.

I grew up feeling closely connected to the music of the Goo Goo Dolls. I don't know why but the lyrics and the sound of John Resnick's voice always helps. The song "Iris" talks about not wanting the world to see him. What did he mean by this? Why did I connect so much with the words? What is so powerful and deep about these songs?

I would listen and love much of the Goo Goo Dolls's music. A few of my favorite songs include "Black Balloon," "Better Days," "Iris," "Name," and "Slide." During a search online, I learned about the life of the lead singer. John Resnick lost both his mom and dad very early in his youth. I started to believe that this pain was channeled into his song-writing and singing. I could feel the deep pain and also the healing that came from expressing himself. The music helped to bring light into my life. I also know of many friends who also love these songs and the light it helps us to see.

I don't pretend to know what John and his band meant by each song. I also don't know John personally and couldn't ask if he was using the music as a way to deal with the loss of his parents. I do believe that whatever the inspiration, these timeless songs helped me heal. During days of sadness and hopelessness, I could connect with these tunes. I felt myself healing and calming down because of this art. If listening to someone expressing their emotions may help, why would anyone deny the value in art?

I now collect art and the pieces I have bring light into my life. I don't have a huge budget, but the pieces I buy mean something to me. They have light and help me feel peaceful. In my home office, I have several paintings, draw-ings, and posters. I have a poster from Joan Miro which is so colorful and unique. I have a street drawing by James De La

Vega where he wrote "Become Your Dream" on the back of a used mirror. His canvas was the discarded objects in Upper Manhattan.

I love all the art that I see. Each year, I visit Art Basel here in Florida. It is wonderful to see so many creations and those interested in them. I feel that art is one of the most important pieces of our puzzle. The music we hear, paintings we love, and pictures we view are so powerful. They can bring light to us even in times where darkness is everywhere.

There is also something very creative about nature. I often spend mornings at the park with my son. I watched a mother duck walking and protecting twelve new baby ducklings. They were so small and beautiful. I loved the light in the four butterflies flying around the blue and purple flower garden at the park. I watched the trees and the bluebirds flying around. This was a real life picture of the creative forces in our world. This snapshot of nature was prettier than anything I could imagine. I found peace in the moment watching these amazing scenes while my son calmly played in the sand with his friends.

It is never too late to find some way to express your own creativity. You can do it with coloring, writing, singing, dancing, rapping, or even walking in nature. I know we find hope when we do creative projects that open up our thinking. We may find that the light in our lives helps us handle our problems. It may even allow you to find love and joy in every part of the life you experience.

Chapter 14

The Artist Struggles

"Be kind, for everyone you meet is fighting a hard battle."
—Plato

A recent study found fascinating evidence that challenges actually improve our mental health. Dr. Mark Seery is an associate professor at the University of Buffalo. His research has focused on stress, coping, resilience, the self, and psychophysiology. Dr. Seery worked on a study titled "Whatever does not kill us: cumulative lifetime adversity, vulnerability, and resilience."

The study shares how typically it is thought that adverse life events cause more mental health problems. The idea is that if you go through a severe problem you are more likely to have post-traumatic stress, anger, anxiety, and other problems. Dr. Seery's study explores whether challenges may foster resilience and end up helping our mental wellness.

They performed a multi-year longitudinal study of a national sample. The research found that "people with a history of some lifetime adversity reported better mental health

and well-being outcomes than not only people with a high history of adversity but also than people with no history of adversity." This allows us to look at how we view major life situations. These issues may actually be something to help us change how we live.

I want to open myself up to share this process. If I walked into a room and revealed my past trauma, how would people respond? I could mention that I was kidnapped at two, my parents had a terrible divorce, I was a childhood celebrity, placed in a mental hospital at fifteen, I, was in five psychiatric hospitals for a month at a time in my teens, I live with a severe mental illness, my brother overdosed on heroin and died, and the list could continue. Many would look at my past and understand if I was messed up. They could point to a jaded history that would justify failure, anger, depression, isolation, and mental instability.

There is some truth that those painful problems changed my psyche. When you are placed in a stressful environment, there are only a few choices. You can sink and let the despair take over everything. You would be justified in feeling worthless or having a negative attitude. I know that many others have faced horrible circumstances.

Viktor Frankl was a psychiatrist, neurologist, and Holocaust survivor. He wrote the classic book *Man's Search for Meaning*, sharing his experiences living in a Nazi concentration camp. Viktor found meaning in the tragic situation he was forced to endure. He said,

We who lived in concentration camps can remember the men who walked through the huts comforting others, giving away their last piece of bread. They

may have been few in number, but they offer sufficient proof that everything can be taken from a man but one thing: the last of the human freedoms—to choose one's attitude in any given set of circumstances, to choose one's own way.

Viktor went on to survive his circumstances and would leave an indelible mark on future generations of psychologists. I took away from him that my hard situations were not an excuse for giving up. I too could gain truth and openness from talking about my battles. His works have helped me to see that our attitude determines everything in our lives.

I always share this story that shifted my thoughts. In my youth, I met many celebrities: Michael Jackson, the Dalai Lama, Paul McCartney, Audrey Hepburn, Muhammad Ali, Patrick Swayze, Dizzy Gillespie, and both Donald Trump and Hillary Clinton. As a child, I aspired to be a star. I wrongly assumed that their lives were filled with joy and abundance. They had money, glamour, attention, and success. I secretly wanted the many gifts their fame seemed to provide.

During my teenage years, I had a friend named Harrison. He is a wonderful person and was one of my best childhood pals. One year, he invited me to ski at his uncle's home in Beaver Creek, Colorado. I went and it was a beautiful place. The mountains were breathtaking and the powdered snow felt like a dream. Harrison is an excellent skier and I am not. I was only used to small mountains and nothing like the ones they have there.

Harrison encouraged me to try and we took the lift up the mountain. The lift seemed to go for miles and I began to feel fearful. I only know how to ski in a V shape and this was

too much mountain. I guessed I was a few miles up and it would take a long time to go down. I started in my V shape and began to fall. My mind took over and made me believe I could really hurt myself. I had a cousin who had just broken his knee skiing into a tree.

I attempted to cut my losses and slid on my butt down the mountain. I made it halfway and then took the chair-lift down while Harrison enjoyed the day. I grabbed a hot chocolate and sat by the fire they had in front of the hotel. It was wonderful as the warmth from the fire helped me heat up. I noticed a young man sitting down who appeared to be my age. We began to talk and get to know each other.

I opened up about my journey meeting notables and writing a book. He began to share that his grandpa was the Prime Minister of Greece. He told me when he turned eighteen, he would be given a large inheritance. The boy spoke of buying a boat and traveling the world. I was interested to meet someone who lives much differently than I do. We spoke at length and became fast friends. A few minutes later, Harrison came down the mountain. The new friend from Greece wanted us to meet his mom. I didn't know what to expect, but I went into the hotel.

In the elevator, he pressed the penthouse and I was impressed. We walked into a suite that appeared to have twenty rooms. I finally walked into a large room where his mom was sitting. She had the smell of wealth and an air of sophistication. She asked me about myself and I told her my story. I shared about meeting many celebrities. I ended just saying I am very happy and love life.

She looked at me with a confused look. Did I say something wrong or insult her? She laughed and said, "I know the

richest people in the world. They are all miserable. How can you be so happy?" I told her that I do my best to enjoy each day. I have had many problems but find a way to look on the bright side. I learned this from my mother.

We spoke for only a few minutes, but this exchange shifted my life. I saw a woman with massive wealth and more abundance financially than I have ever known. She seemed to have it all, yet she did not have happiness. I began to think that maybe the stars I chased didn't really have joy. Was I searching for something that would not bring lasting happiness? Had I been trying to obtain something when I already held something even more valuable?

I would find as I grew up that being a celebrity did not mean you were automatically happy. There are some who do well, but many who fall apart under the bright lights. I also find that facing early trauma has helped me keep life in perspective. Most problems seem pretty minor in comparison to the major issues I have seen. You can take anything from me, but you cannot take away my hope. It is not always easy to keep pressing forward. I face adversity all the time. I believe the work of Dr. Seery and Dr. Frankl is correct. We can take the problems that enter our lives and through work have a better outcome. We learn that no matter how dark it may seem, our mind has the power to allow the light to shine over our weary heads.

Chapter 15

Creating a Coloring Group

We may enjoy adult coloring either alone or in a group. The benefits of group activities are numerous. They include connection, support, teamwork, and consistency. It is also possible to set up a coloring group at a school, company, university, church, therapy center, hospital, or senior center. My framework for a coloring group is meant to be a model. I openly share it in hopes some brave souls will begin their own groups.

The first step is to identify what type of members you hope to attract. Will it be an open group that anyone can attend? The main part of identifying potential members will be helpful in determining how to recruit participants.

I am going to give two examples to help determine ways to grow a group. The first is an open group that is promoted to the public. This would mean you have a greater potential to have all types of members. In group A, you would first need to find a space to hold the group. A few ideas are to use an art gallery or loft that has a quiet time in the evenings. They may either volunteer the space or charge a small fee.

There are other places to hold an event that may feel easier. A couple of potential places are your local library, a church, restaurant with a meeting room, hotel with a conference room, office with a meeting space, and possibly a start-up office center.

I would begin by looking online to find a space. You could search meeting rooms in your desired city or town. You may decide to call local places as mentioned above and ask if they have a meeting area. In my town, Dunkin' Donuts offers a meeting room that is free to use. I have heard of other chains, including Panera Bread, providing rooms for free. It may take some effort, but you will find a location that will allow you to hold the coloring group.

The second step is to narrow down how the group will operate. Do you plan on members bringing their own coloring books and pencil crayons? Will you provide everyone with a coloring book or loose sheets of papers with designs they can color? Are you going to give everyone colored pencils, crayons, and markers? Should everyone plan on bringing their own supplies or do they just show up?

There also are ways you could have themes within the group. An example would be each week you are coloring different patterns. The first session may be animals and would include coloring pictures of horses, birds, elephants, dogs, cats, and other species. The next week may be coloring nature scenes and could include trees, flowers, and grass.

I would encourage the group leader to have a plan for each group. You would want to know that this week you will be focusing on a certain type of coloring. Even if you choose to do it with no structure, the group leader must have some ideas. For example, the leader must determine what time the

group begins and ends. If you are borrowing a room, you may not have access to it all evening. You would want to tell the members up front that the group runs from 6 p.m. to 9 p.m. It would become confusing if people don't know how long or when they are allowed to be there.

You may also set certain ground rules you feel comfortable with. This may be letting people know if they can eat or drink during the group. Do you allow them to drink wine or is that not something you want at the group? Will the space allow alcohol or food to be eaten in the room? You may also have attendance policies. Do members have to arrive at the exact start time? If these details are clear, you may have a better chance for success with the group. I have found that sometimes the first event has some showing up late. They may struggle to find the location or have delays. It is helpful to determine if you will keep allowing new members or if only the same people are allowed to come back week after week.

The next step is to determine frequency. You may want to do the group once a week. This will allow a consistent meeting that becomes a large part of every attendee's life. You may choose to do it for four, eight, or even twelve weeks in a row. If your time is not as available, you may choose to do the group bi-weekly or monthly. There is also a chance to do it daily, especially if you work in a hospital or school. You may find that doing a daily group is a fun activity that can be done often. I also envision that you could hold a coloring party for a special event. This might be celebrating a birthday by having a large group come together to color. You also may hold a party just once to have a group come together to color. It could even be a benefit to help raise money for a charity or special cause.

This brings us to determining a cost. I have done many support groups and always find it difficult to charge. I was helping the group members but realized it also took much effort. If you are going to run a coloring group, it will take a great amount of time. I believe you have a right to charge and even make a profit from your group. I would think carefully about your fee and what would work for you. If you charge $20 a group and have fifteen members, this would generate about $300. The room may cost $100, so you would have $200 left. If you bring the materials, including coloring books and crayons, you could easily spend another $100. When you promote the group with paid ads, you would possibly spend another $100. This would mean that the group would not be profitable.

The way to turn it into a money-making venture would be to find a free room, make members bring their own supplies, and do free advertising. It still would be work but you may end up making some money from the group. This leads us to figuring out how to find others to attend your group. This only applies to groups that do not have a set list of members. A teacher starting a group for her class already has a predetermined set of participants.

When you are going to reach out to the general public, it can take effort. I have learned over a number of years a few tips running groups. The website Craigslist.org has a section called groups in each area. They allow you to post one to two ads on this section. You would create a posting to share information about the coloring group. You could mention what type of coloring, day, time, cost, and location. You are allowed to include your phone number and email. They sometimes allow you to put a link to a website, but

not always. This is a great option because many look in the group section on Craigslist for potential activities.

I have recently been using Groupon.com to promote some of my work. I find that Groupon has a unique business model. They have a policy of not charging up front to create a Groupon. It works in this manner: you set up a Groupon to offer an adult coloring class. The Groupon costs $20 for one meeting. Groupon shares this with thousands of members who subscribe to their emails. They also have it on their website and app that is available to millions of people. If someone buys the Groupon for $20, you are given $10. Groupon keeps $10 for doing the work of promoting, selling, handling payment, and other details. This helps you promote your event with no up-front cost.

You may choose to use Google Ads. Google charges each time someone clicks on your ad. You would also need a website to send people to. This can be a costly option. You may also use Facebook ads but I know this also would take an up-front investment. There are other online services that may or may not help.

There are some non-online ways to promote your event. A simple flyer can be made and have multiple copies drawn up. You may place them at gyms, restaurants, Laundromats, or anywhere people may see them. You could list your number, talk about the group, and tell people to call to sign up. This may help spread the word in your area. It should only cost about 2 cents per flyer so it would not be that expensive to try this.

I know some of us have experience with marketing and publicity. One other idea is to find a local paper, television outlet, or blog to share about your class. You could call or

email them and ask if they would want to do a story about it. It is possible that the local media may be interested. This would reach many people and cost nothing if you do your own publicity. There are many newspapers and local magazines that have a calendar. I suggest reaching out to them a month or two before your first event. It is possible to be listed in their calendar of local events. This sometimes is free and is read by many. This would help to draw attention and possibly lead to members signing up.

One of the hard parts of groups is keeping them going. If you are doing the group for six weeks, you may want to charge up front. I found that allowing people to pay weekly sometimes causes problems. I had one group where one person paid for six weeks and others did not. When he was the only one who came back each week, I had to refund his money. I find that often people are excited to come the first time, but do not return. This can be a problem and it is important to keep momentum with a group. If everyone pays up front, you are more likely to see them return. It is also helpful to collect their emails and phone numbers. You could call them each week to remind them to attend the group.

I have talked about promoting the group, but it is important to go over the specifics of running it. It is best to have an idea of what the plan will be for each group. The beginning might be an introduction. You are able to ask everyone their names. It is helpful to introduce yourself first and share why you started a coloring club. It may be that you love art, find coloring peaceful, or just wanted to make some friends.

One idea is to pick a drawing that everyone will work on independently. You can give them fifteen or twenty minutes

to color in the drawing. When you finish, you can have everyone pass around what they created. This would open up the forum to share feedback. You may ask that members only say positive responses so nobody feels hurt. It is even possible to have a vote to determine which are the top three pieces of the class. It may mean buying a little sticker or prize you give to those who came in at the top.

I believe many of us enjoy coloring with music. It may be fun to bring a phone or music player. You can put on a mix of songs that you believe members will enjoy. This will create a more lively environment and hopefully will be well-received. There are some therapeutic aspects of coloring you may want to examine.

This may mean asking members what they feel when coloring. You can create a discussion about how coloring is helping open up their self-expression. It may lead to some members talking about painful problems that they use coloring to avoid. This could become heavy, so it is up to you if you want to go this route. There are some who are trained as therapists and would enjoy their members talking about their problems. For some, it may feel overwhelming and would make the mood heavier than just having fun.

I find that groups in a structured setting may be better suited to heavier discussions. A teacher, nurse, or therapist can use coloring groups to help others learn. They may use the coloring activity to work on a particular subject. This may mean doing coloring and then speaking about bullying, anger, holding in our emotions, or anxiety. I know that there are so many possibilities for running a group.

I have run about fifty groups over many years. They range from support for actors, a brain cancer support group, doing

rap therapy for youth, bipolar and depression support, and parenting groups. Each group takes on its own shape and way of being. There have been times when running groups helped create breakthroughs. I found in some that being with others helped them change and grow.

There are other groups where everything doesn't work. This includes having a member who is disruptive or angry. I have had a few where people complain and don't like whatever activity I propose.

You may have to develop thick skin if you are running your own group. You do not know how others will react and respond. It may also be confusing to try and lead the group if they are not happy being there. I have learned being flexible and listening are tools to be a good group administrator. When someone has a concern or issue, I listen and try to see if they are right. I also ask other members if they too feel the problem is something that needs correcting.

It is brave to start anything. If you have the urge to start a group, you are encouraged to do so. I find going slow and planning helps make things better. You may want to think of the group from an attendee's perspective. Are directions and times clear and easy to understand? Is the group's cost and location convenient and affordable? Does the group leader help make everyone comfortable and have a good way to handle issues? Is it fun and something you would want to attend each week?

I remember running bipolar support groups in Los Angeles. There were some that were wonderful and others that flopped. The hardest part was that so many had their own idea of the perfect group. They had a set idea of exactly what they wanted. I could never find enough people to create the

ideal group that everyone wanted. I ended up giving up running the groups because I found that it was frustrating trying to please everyone. I also found that so many were interested, said they were coming, and then didn't show up. I realize that attending a group is not always the main priority for everyone.

These words of caution are not meant to be negative or stop you. I want it to be clear that running any group is a big task. It will take effort and passion. You must be prepared to handle the many issues that will arise. With this being said, there are still many unique spins on adult coloring that could be turned into a group. This may mean a coloring group for parents with their children, one for Christian, Jewish, or other faiths, singles, seniors, and the list goes on. With the right planning and creativity, coloring groups can become a wonderful place to connect.

Chapter 16

Mixing Meditation and Coloring

The term meditation is defined by Webster's Dictionary as "the act or process of spending time in quiet thought or an expression of a person's thoughts on something." The act of meditation has become more accepted and common within Western cultures. This has long been believed to help us slow down and erase the nervous chatter within our minds.

In a study that appeared in *Psychiatry Research: Neuroimaging* (January 2011), a group of Harvard researchers looked at meditative benefits. They studied a group of participants in an eight-week program of meditation. Each participant spent about twenty-seven minutes doing meditation. The results were quite interesting.

The research team found that participants had decreased gray matter in the amygdala. The amygdala is a mass about the size of an almond. It is grey matter inside each cerebral hemisphere involved in our experience of emotions. This means that people may actually be calmer and better able to handle emotional issues when meditating.

The team also looked at the impact of meditation on the hippocampus, an area of the brain that makes up part of the limbic system which plays a major part in regulating our emotional responses. The study found more gray matter density in the hippocampus, which impacts learning and memory.

This study helps us realize that meditating actually plays a role in changing the brain. How cool is it that we can do something so simple and free to change our minds? The coloring books we use are a way to handle our feelings. What would happen if we take adult coloring and then mix it with meditation?

I propose a new activity that has yet to be studied by any known researchers. It is to do a combined session of coloring and then meditation. It would mean that you possibly spend fifteen minutes meditating and changing the thoughts you are holding onto. You would then start to work on your coloring. How would our minds handle the mix of both calming meditation and creative coloring? Would we be both relaxed and then positively stimulated by the coloring? Would we enter an emotional state that is partly euphoric, combined with peaceful and relaxed? I challenge researchers to make this a real study. You could put together a group of adults with many different backgrounds. This would mean those of different ages, ethnicities, financial brackets, and even health statuses. Would these people's brains actually improve by doing something that seems so basic? If we tested over a longer period of time, what would the results show?

Is it possible these individuals would improve in their anxiety levels, blood pressure numbers, food choices, career success, and improved friendships? What happens when we are put together with others who are all looking to relax and

feel happier? Do we end up all collectively improving our way of being? I challenge the researchers to do this study and see if there is long-term success.

If it is scientifically correct, why not invest more money in these activities? What would happen if inner city children were taught to meditate and color in their youth? Would we decrease the gun violence that is all too common in inner-city neighborhoods? What about the mental hospitals where children and adults are forced to stay during a psychotic break? Would these patients improve by meditating and coloring? Do we have so many school shootings in part because mentally ill children are angry about the horrible treatment they have received? Did years of bullying and isolation cause them to create a tragedy?

There has to be better ways to engage our minds. We have far too many citizens walking around depressed, angry, isolated, and hostile. I used to work with the homeless and found one main recipe for helping them. It was to connect with them and show them love. I would listen to them and really try to hear what they were saying. I would not judge them, even if their discussion didn't seem to make sense. I understand that years of being homeless and alone can chip away a large amount of one's dignity. I didn't need to judge them and make them feel bad for a possible mental illness. Many just wanted someone to be nice and listen to them. They were so alone and longed for the human connection that many were lacking.

While I sat in a soup kitchen with one hundred homeless human beings, I began to see something. They wanted hope and friendship more than they needed money. They were trying their best to survive hard and lean times. I rarely saw

violence or anger in those rooms. I understood then, and now, that love is the number one factor in our lives.

We cannot defeat terror attacks and school shootings. We need to build a society where those who are outcasts can fit in. It should be a place where we come together no matter what we have been through. It is so sad we live in a world where we can never truly feel safe. In the last year there have been attacks at colleges, high schools, movie theaters, restaurants, concerts, and many other locations. Are we helping the mentally ill enough to stop the next generation of killers? What would happen if a potential killer was helped in their youth? Would we stop someone from doing harm by teaching them healthy ways to express their confusion and unhappiness? If we helped them find their place in our big world, would they not want vindication? Would these troubled youths no longer feel ostracized and forced to gain negative attention?

I live in Florida and we recently had an attack in Orlando. I don't know all the details, but the killer seemed sick. He was possibly gay, consumed by anger, and didn't seem to fit in during his working years. Was this an example of a lost soul who hurt others just to gain attention? When we splashed his whole life all over the news did we inspire some other sad young person to do the same thing? I know our schools are filled with kids who are bullied. What if the teachers intervened and didn't allow this to happen? What if we had groups where young people could find the security to open up about being mentally wounded? How about allowing these bullied children to have the support and help to handle their emotional scars?

We instead do nothing and feel horrible anger when these attacks occur. It is time to change the way we train our

educators and our young people. The tools to let go of stress are free and easily available. We could save millions of lives by creating programs to help troubled youth. I would love our next generation to take these ideas and spread them to their peers and institutions. We are meant to be in a world of love and hope.

When the weak become terrorists, it kills all of us. We all live with fear wherever we go. Is this the kind of society we hope to live in? I don't want my own children to walk around feeling fearful. How sick is it that going to school or a movie has to cause us concern? We need to live in safe communities where everyone feels loved. This will help our physical and mental health. It will also teach us that loving each other is worth investing all the effort and resources we can.

Chapter 17

Healthy Escapes

The Great Depression was a time of confusion. There were countless Americans struggling to hold on to hope. It was common for citizens to feel overwhelmed by financial problems, sadness, and fear. This historical time period is ideal to help us understand how escapism is used during hard times. Alan Brinkley is an historian who has taught for over twenty years at Columbia University. He has written amazing books that examine the causes and consequences of the Great Depression and World War II.

I found and read *Culture and Politics in The Great Depression*. In it, Professor Brinkley helps us understand the psyche of Americans during these days. His book outlines how many would assume that Americans would grow angry and hostile. The response would be to believe that their country has failed them. They would be upset that the whole country is struggling and that consumerism needs to change. What they found was remarkable and took me by surprise.

Mr. Brinkley discusses the work of sociologists Robert and Merrell Lynd. They went to Muncie, Indiana to research

a famous book they wrote called *Middletown*. In the 1890s, Muncie was a Victorian town. By the 1920s it was booming financially. The residents were awash with abundance and financial success. They had a new set of values now that they were wealthy and successful.

The Great Depression then struck the whole country and Muncie, Indiana. In 1935, ten years after the first book, the sociologists went back to this town. Brinkley writes "the great knife of depression had cut down impartially through the entire population, cleaving open the lives and hopes of rich as well as poor." The sociologists assumed that residents would be up in arms and requiring changes.

The truth was far more interesting and shocking. The values of the people were the same in 1925 as they were after the Depression had struck them. The families didn't blame the times or the economy for their failures. They put it on themselves that "they were not succeeding." They believed it was their own personal failings and that they were to blame. How do you succeed when everything is failing? Is it a man's fault for not finding success when there is none to be had? Their answer was that it was your own fault if you were not a success even though all were likely failing financially. What did people do? The fascinating truth is many lives had changed. The women were often more able to hold and keep their jobs. They worked as nurses and teachers who often stayed employed during a crisis. This left many men out of work and blaming themselves for failure. They often lost their business or couldn't find a job. Many of the men kept trying to find work day after day, instead finding only frustration and negative results. These men would beat themselves up emotionally and secretly hide their feelings.

This is when escapism became a common part of our culture. The times were filled with movies and books that were light and funny. They often had someone who struck it rich. There was little talk about the real problems or the pain many were in. It was easier to escape and pretend that everything was going to be alright.

These days, we have been in a similar great depression. The mainstream media won't talk about it and the stock market miraculously never seems to fail. This is despite companies having poor earnings and many doing worse than they hoped. Yet the most popular show of this time has been *Keeping Up with the Kardashians*. We watch as they fly around the world and live a dream life. While so many are broke, the Kardashians keep enjoying a lavish lifestyle and traveling the world. I am not surprised when Kanye West admitted he was broke, that the story quickly went away. Who wants to keep up with the Kardashians if they are as broke and unhappy as everyone else? It doesn't make for great escapism if they are having money problems. We would rather watch as one husband becomes a woman, another husband ODs in a brothel, and the third husband faces losing his wife for a fling on a vacation.

I have nothing against the Kardashians. I think they are smart for creating a television family that keeps us entertained.

What is it in us that wants escapism? Can it actually be healthy to have some escapist behaviors? I know it is a mixed bag. I have met parents who have children that are bullied. They become upset and don't want to live in the world. They escape into video games and are often lost forever. They may never make friends in person or even come out of their

rooms. I have seen some children grow extremely overweight and addicted while being lost in their escape.

Then there are some children and adults who seek a safe amount of escapism. They watch a movie once in a while that is funny and helps them not think about their problems. Some of us play video games or app games a few minutes a day. It is enjoyable and helps us stay calm. There are those who read science fiction, adventure stories, and romance books—which we love. I find nothing better than having a break once in a while to sit with a great book. It helps change my thinking process and is one of my favorite hobbies.

We then look at adult coloring. Is there some escapism while coloring? The answer: of course. When we color we are not worrying about our overdue bills, hanging up on bill collectors, or fretting how we can afford our lives. This escape is affordable and we don't overdose on coloring. I find that healthy escapes are awesome in moderation. We can take some time to leave our worries behind us.

I share all this as I still go to therapy. I still go to open up about my feelings and be honest about what I am facing. I have learned long ago that I cannot escape my reality. If I do not deal with my problems, they become worse. When you have the courage to share what you are feeling, you may make positive choices. I also know that it can be hard to battle everything by ourselves. When we talk about what we face, we may grow happier. I know that after the Great Depression came World War II. I pray that we as a society are brave enough to face our financial issues with love instead of war. If we begin to change how we live we could avoid the next World War. If we do not, I fear we will escape

until there is nowhere left to go but to war. This will hurt all of us and create pain that we have never experienced. It is up to us to choose where the future leads.

Chapter 18

Parenting, Coloring, and Kids

I have done all types of work in my life. The most fun and rewarding has been being a parent. I have learned a new set of skills that being a dad has brought into my life. These include changing a diaper, developing endless patience, and focusing on teaching my children new skills. I am not alone in feeling that this is some of the best, but also hardest, types of responsibilities.

I recently said to my mother that I try not to let my kids see me sweat. They don't have to know how much my wife and I juggle working, paying bills, and the many parts of parenting. This is why I have always tried to find ways to let go and allow peace to enter my mind. When you have young children, it is rare to be given a break. We may work five days a week for forty hours, but parenting is a seven-day-a-week concern. It knows no limits and the work just keeps continuing.

I say all of the above while sharing that being a dad has helped me grow up. It has made me more careful, responsible, loving, and happy. There is no material object that can feel better than coming home and your child looking and

saying "Daddy." The way they light up and are so genuine is refreshing. I find freedom in choosing how to provide them the happiest life possible. I also understand my own parents' journey and what a struggle it must have been. There are no easy days when it comes to being a parent. You must do your best at all times. Your kids are too important to let an accident or other big mistake harm their futures.

The part of parenting that has helped me is finding creative ways to be together. I have shared many more research-based theories in this book. I want to look at my own life in this chapter and show you how real situations have happened for me. It was the Tuesday after a long July 4 weekend yesterday. My wife returned to her busy day as a physician's assistant at the University of Miami. I returned to my role of full-time father, author, coach, real estate agent, and friend.

We woke up and I took my daughter to camp by 8 a.m. I then went back to my neighborhood and took my son to the community playground. It was already 90 degrees and humid by the time we arrived. My two-year-old son Ryan lasted about twenty minutes before he said, "Let's go bye bye."

Our refrigerator was nearly empty because we all ate a great amount over the holiday weekend. I went over to Walmart and began to grocery shop. I found all that we needed and returned home. I put my son down and then unpacked all the food. The next few hours were stressful, trying to complete this book, handle some other business, and plan for my mom to come for a visit.

She arrived and I went to my counseling session. I had not been there in a while and wanted to talk about some of the changes in my life. I had a great talk with the counselor,

but felt kind of emotionally drained after it ended. I went home, then picked up my daughter from camp, and by 6 p.m. was quite tired.

My daughter Tyler is amazing. She is beautiful, funny, warm, and outgoing with all types of people. My wife came home from work and was more tired than usual. My son was playing with his Thomas the Tank Engine train and seemed fine. My daughter Tyler was bored and didn't want to sit at the house. I could see my wife needed to rest and wanted to stay in. I agreed to take Tyler out and went to Toys R US.

We went into the store and looked at all the toys, games, bikes, and other fun stuff they hold inside. I am pretty strict about the amount I give my daughter to spend on toys. Most weeks, I go once to Toys R US. and allow my daughter either $5 or $10. I told her she could spend $10 and she searched the store. Tyler visited the jewelry section, Shopkins collection, remainder items on sale, and more.

We made it around the store and she found a game called Pie Face Game. My adorable daughter said, "Dad this is so fun. I saw it on YouTube." She said it is a game where you put whip cream on a toy hand and then spin a number circle. If you have a 4, you have to crank the toy four times. It may or may not put whip cream all over your face. At first I thought this was a terrible idea.

I was tired and didn't feel like going home and playing a pie in my face game. I knew my wife wouldn't really find it amusing to be hit with a pie right before bed. I walked around and told her it was over the $10 budget. I then thought about it and asked myself what I should do. I began to remember what happened on July 4. My family and I went to a festival where they had kids rides and games for

free. The downside was that the lines were about 150 people long.

My daughter was so excited to go on a silver swing ride. She would soar through the air and her mom would do it with her. Tyler was patient and waited with the long line. About an hour and a half later of waiting it was almost her turn. A group of ten girls pushed in front of her and cut her in line. They made it on the ride and my daughter would be next to go.

A worker at the festival came over and said, "The ride is now closed. We have thunder warnings and the ride is not secure. Nobody else can ride the swings." I never saw a sadder face on my daughter. She was so patient and then was not allowed to ride. I felt horrible and she was crying so much. I was trying to cheer her up and told her I would give her $20 to get a toy.

I had almost forgot my promise the next day at the Toys R US. I thought about it and realized I did offer her the money. I also thought how calm she was after being so disappointed. We spent the $20 on the pie face game and headed home. We grabbed some ice cream at Dairy Queen and both of us were smiling. Tyler couldn't wait to get home and play the pie face game.

We set it up and put Cool Whip on the hand. She started to spin the dial and rolled a 3. She cranked it three times while putting her head in the hole where you could get pie-faced. The girl has luck and nothing happened. It was now my turn and I feared I may not have the luck of the Irish. I rolled a 4. I began to turn the handle and "Splat." The hand slammed a load of Cool Whip right on the middle of my face. It was both funny and silly at the same time. We

happened to film it for my daughter's YouTube channel. We could relive the moment of glory forever! Lucky me!

I share this story because creative outlets are amazing for kids. They also help parents to find positive ways to deal with stress. When our kids are busy creating, they are less angry, frustrated, nasty, and attention-seeking. I find all types of ways to create fun experiences while watching the kids during long days.

So how does adult coloring work with our kids? There are some adults who say, "This is my time. It is called adult coloring because it isn't meant to be done with kids." They are correct, and there is so much value having your own time and space. It may be fun to be free and not do coloring with anyone but other adults. This sounds fantastic, but there is a different reality when parenting. We often juggle so much that it is rare to have two hours to just sit and color. When your kids are bothering you, it is tough to have them sit quietly while you do whatever you want.

This is why I have found ways to be creative with them. A few days ago, I bought some large poster boards at Walmart. I drew some pictures on them and then asked my kids to color with me. We were together hanging out and having fun. I watched as my seven-year-old feverishly colored within the lines. I took a blank sheet for my two-year-old and let him go to town. I didn't worry that he is too young to color within the boundaries. I let him have fun and feel part of our group.

We all seem content when coloring. There is a freedom and joy in something so simple. I also find that we are enjoying each other. My kids feel happy when I include them and let them be a part of my projects. I find they want to

do whatever I am doing. This is why allowing them to color with me goes well. We feel connected and joyous doing a project as one.

When I first had a child, I was so serious. I wanted to not drop the baby, read every book about parenting, and make sure they were thriving. When the first poop diaper exploded on my couch, I knew there was no book for that. I began to see that parenting is something you must handle in your unique way. I am free-spirited and creative. This has helped me teach our kids how to have fun, sing, rap, dance, draw, paint, and create games. I show them that having free time for healthy outlets is vital. I also created a YouTube channel where my daughter shares her lessons. I am teaching her to have a way to express her own unique personality.

I, of course, have to create rules, structure, and handle schoolwork. I make my daughter do her assignments as soon as she comes home from school. I also fight with her to brush her teeth, take a bath, and comb her hair. These are items my wife and I work on all the time together. We also mix the serious stuff with fun ways to let out our energy. I find that coloring and art projects are some of the best uses of our free time.

It is possible to help your children learn about self-expression. When I color, I often talk to my kids about what we are doing. I ask them how it feels to color. I then ask them if it helps them to calm down or what they are thinking during the coloring. My daughter says it helps her to be calm and she has very few thoughts during the activity. I admit to her that I also don't think very much while coloring and it is a nice break.

There is a secret reason I teach my kids to color. I want them to know there are other ways to let out our emotions.

I watched my little brother become an addict, and it killed him. My brother was so creative and artistic. His artistic abilities would put mine to shame. I sadly think he found drugs as his escape from life's problems. His death from heroin teaches me that this road is a dead end.

I want to help my children learn they can find ways to express themselves. When they are sad, we can openly talk about it. There is nothing off limits in my home as long as it is honest and authentic. They will learn that you can color, create, and find tools to deal with problems. The goal is for them to find healthy outlets to deal with emotional burdens. It is my prayer that they choose these ways to handle life's ups and down. If I can help them avoid the addiction issue in my family, I may save their lives. In a way it would be saving my own as I love them more than anything in this world.

Chapter 19

Liberation of Your Life

What does it mean to be free? It can be as simple as being able to choose what you want to do in this moment. There is a powerful part of creating art that is being open to freedom. We can choose to create what we want and how we decide to share it.

There are countless examples of artists creating works that are controversial. During the 1990s, I remember reading about a controversy with the mayor of New York and an artist. In 1996, British painter Chris Ofili made *The Holy Virgin Mary*. It depicted a black Madonna figure showing one breast. It was made from lacquered elephant dung. In 1999, the Brooklyn Museum of Art was ready to display this creation. It made a media sensation when many Catholics and then mayor Rudolph Giuliani were against it being in a public museum. Rudy even threatened to pull funding from the museum for this work. The city would eventually lose because the museum argued it was free speech. Therein lies the issue with art and liberation.

Do some of the greatest works sometimes have viewers that consider them disgusting? Was Ofili's dung masterpiece genius or gross? Do we have the right to take a holy figure like the Virgin Mary and put feces all over her? This is a tough question that will have many varied opinions. I am sure religious believers will feel justified in thinking this is immoral. There will be free speech advocates who will say you cannot tell anyone what to create.

Elist10.com is a website that offers amazing articles. In "The 10 Controversial Paintings In Art History" the site discusses works that were considered offensive. One example is *Rokeby Venus* by Diego Velázquez. This painting depicts nude women and was created in the seventeenth century. The Spanish inquisition was extremely against paintings depicting nudity. It goes on to share that in 1914 someone attacked the actual painting in public. The woman and attacker later revealed she was angry that male visitors would gaze at the naked women all day long. She took her frustration out on the painting.

There are other examples of paintings that are both loved and hated. A fascinating art story is about the work titled *My Bed* by Tracey Emin. It was created in 1998 and shown at the Tate Gallery in London. The work is a bed that is surrounded by objects. The artist said she was in bed for several days just drinking alcohol. When she looked around her room she was inspired to create this.

The work included stained sheets with possible bodily fluids, old cigarettes, condoms, underwear with menstrual stains, and her slippers. This was considered gross and vile by some. They believed the artist had gone too far in her creation. In the art world, some found it to be genius. The

debate on this painting is still mixed. What would happen to this work? Would it be worthless or worth a fortune? Some may want to burn it but others may want to buy it.

If you are not familiar with this story, I want you to guess the value. Would someone pay $1,000, $10,000, or even $100,000 for this? What would be a fair valuation for a piece that garnered so much controversy? It was auctioned by Christie's in July 2014. The final auction price was 2.5 million pounds. Even with the pound being worth much less in 2016, this would be the equivalent of 3.2 million dollars. This is more than the annual salary of sixty full-time teachers in my town. A collector was willing to pay and may even end up making a profit.

So how do we decide about liberating ourselves? Do we think about our religious or ethical values before creating works? Would a devout Christian or Orthodox Jewish person have a different set of values than an Atheist who does whatever they believe? Should we hold ourselves back or embrace creative freedom? This is a complex question that only the individual can accurately decide.

I try to follow the boundaries that feel most authentic for me. I had a brother who loved going to nudist resorts, having group sex, taking all types of drugs, and pursuing wild adventures. This never felt appropriate for my life. I did not condemn him for his way of living. I shared that drugs are dangerous and have consequences. When he died, I was in shock, but not surprised. I correctly assumed that living too close to the edge might mean one day he would fall off a cliff. When he did one laced needle, it would be his final adventure here on earth. I am sad but believe that you cannot force anyone to be anything they don't want to be.

The coloring we do can liberate our thinking. It is possible to help open our minds to new and different ways of feeling. At first I thought coloring as an adult was silly. I would grow to embrace it and love the feeling of doing something different. It led me to start drawing and eventually painting. This liberation came at a time that it was needed most. I was bored and feeling sad. The creative arts helped to open my thought process and to let go of resentment.

We can all be liberated in our own ways. I recently went to the bookshop and found a plethora of adult coloring books. There are Christian-themed coloring books which many of this faith will find are within their belief system. I have seen others about nature that appeal to enthusiasts of the outdoors. It is possible that the future will present coloring books that appeal to all types of belief systems. My friend even shared how she went to a foreign country and found these books translated into her language.

I don't think liberation is the same for all of us. The most devoutly religious of our populations will never have orgies and coke parties. The wild times some experience will never be lived by most of us. It is not my goal to judge or tell you what liberation should look like in your own life. It could be as simple as going outside more, creating art, and visiting the beach. For others, it may look as fun as my brother's life. I have heard stories of people dancing the night away while completely naked. They then have multiple sex partners and do things I don't even know about. There are some who are gay or lesbian that live monogamous relationships. There are a few who meet at random spots for quick public sex. I do not judge them but no, this is a liberation I will never experience.

I find art to be much similar to our world. There are some who will love paintings that only show wholesome and happy images. It appears many love arts that evoke a message or feeling. They may connect with artists that were struggling and used their work to send a message. It may even be that what is risqué and offensive today, will be pretty normal in a century.

In my childhood, I remember buying a CD by Two Live Crew and the band Anthrax. They both had labels on them that they were "Adult" and meant for mature audiences. I remember sitting in my living room with three childhood friends. We were about ten and listened to the cassettes. We all were excited when we heard the bands say the word "fuck" and "take no shit." We knew it was inappropriate and that was the point. We were listening to something we were not supposed to. I was cool because I had an offensive and dirty cassette. I am sure many of us have had similar experiences. I will never forget the first porn magazine I saw as a youth. The kids who had it felt like we had found the holy grail. We felt so excited and, though it may have been wrong, we knew no better.

I suggest you find what feels best for you. I may have offended some by the talk in this chapter. Others will say I am a prude for even considering how religions may find art offensive. There is no right answer and the debate will rage on. It seems no matter how far we go, there is always someone who is angry. This election cycle has shown me just how much hate is alive. I feel some are more passionate about hating Donald Trump or Hillary Clinton than actually thinking who would be best for the United States. It is what it is, so liberate in your own way. You can find your own truth and figure out who you were meant to be.

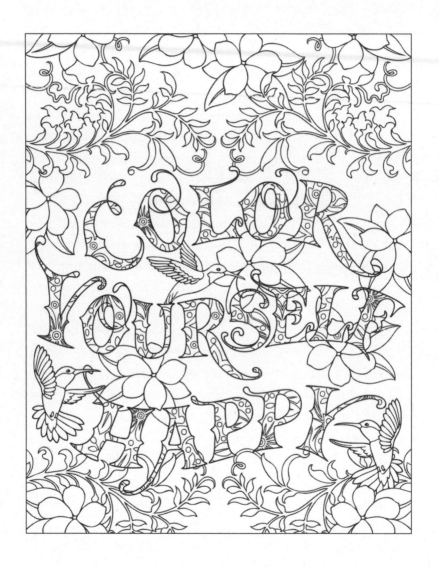

Chapter 20

Letting Go

How do we learn to let go? I believe that many color while trying to handle some heavy emotional burden. If you have cancer, depression, addiction, or are isolated, it may help to color. The act of shading and coloring may help relieve the persistent thoughts of sadness or anxiety.

I was working with a woman who had a child with brain cancer. She shared how painful it is to know that her child may be dying. I agreed that her situation was extremely difficult. In my therapy, I had no easy answer to take away her pain. She shared about handling huge medical bills that she could not afford. There were stacks of outstanding bills she had to go through every month. This is on top of the draining work of caring for her sick son.

I began to think about letting go and how it is vital in our lives. This woman was in a situation that was out of her control. She could not make her son well and take away both of their emotional pain. It was a very rough road that I am sure felt worse than these words describe. I know this mom

had faith. Even though the walk seemed hard, she would not give up hoping.

In my youth I used to collect autographs from celebrities. I did this from around ages six to seventeen. It was very exciting meeting many of the greatest stars of those years. During those years, I made many friends with other collectors and photographers. We would often hang out daily waiting for these famous celebrities. During my quests, I often went to California to obtain autographs. It seemed that Los Angeles was even more star-filled than my home in New York.

I made a friend named Rich who I lost touch with for several years. I had moved to Los Angeles as an adult with my wife and daughter. One evening we were at the Los Angeles County Museum of Art. I saw lots of limousines and my wife and I were curious. It turned out there was a star-studded event at the museum. There was a barricade and a few photographers and collectors waiting. We saw Tom Hanks, Nicole Richie, and Olivia Wilde.

One of the collectors recognized me and asked if I was Blake. He had remembered meeting me in my youth. I asked his name and it was Rich who I had met years before. We became Facebook friends and I reconnected with him. I would not see Rich for a long time after this and then noticed a posting on Facebook. He was hospitalized with diabetes and would have part of his foot amputated. This kind and loving man was facing a very challenging and unexpected issue. I wrote to him and told him I would be praying for him. He said he would have faith even though it was hard. This led me to think of how often we try to believe but harsh circumstances overtake our positive thinking.

This leads to where letting go and coloring intersect. There will be moments when we are so upset that we feel hopeless. This includes times that the situation is so bleak we cannot even comprehend what has happened. What would it mean to take some time to let go and color when these tragedies are around us?

I try to carve time in my days for coloring and letting go. It is so hard to relax, especially when we are trying to deal with a major issue. It may be that even a few minutes being alone and creative may help. I have read that many cancer and other terminally ill patients enjoy adult coloring. I hope for them the simple times of doing this activity is a healthy escape. It may not cure them of their disease but it may give them a few moments of happiness.

I have an uncle named Jack who is a wonderful human being. He is from Brooklyn and is always kind. He retired a number of years ago and began volunteering at a local hospital. When my grandmother had a stroke, she was in the Boca Raton Regional Hospital, and I was able to find out what Jack did. His position had two parts: one was driving a shuttle to help people get into the hospital without having a long walk. This was especially helpful for the many elderly patients that were coming and going. The second job was to bring a dog into many patients' rooms. The therapy dog was there to allow them to pet him and enjoy his calm nature. Jack would go all through the hospital allowing patients to interact with the dog. Did this brief break help them? Many would spend their days lying in bed, having blood tests, facing severe health problems, and more. This time was a welcome relief from the real pain many were enduring. I also watched how Jack would light up whenever he was helping

someone else. He knew that being warm to others assists him in having a purpose.

We may never know the struggles of those around us. The facts for some may be so grim that they are barely holding on. When you are kind you allow warmth to surround others. I know that letting go is often hard. We may be angry, upset, or even confused. If you let go of the past, you make room for the future.

This doesn't stop real issues from arising. I wouldn't ask Rich or the parent of a cancer patient to not have concerns. That would not be realistic or even smart. They may have to handle some of the complex issues that come from their situations. Many of us will at some point in our lives have someone close to us experience something tragic. A few minutes of letting go may give us a break from the pain. This can only allow us to make it through something that even a short time ago felt impossible.

Chapter 21

Creating an Adult Coloring Teaching Lesson

I shared about creating an adult coloring book group in an earlier part of this book. I want to devote this chapter to how teachers can create a lesson plan that includes adult coloring. My hope is that a teacher or professor will find this helpful for engaging their students.

Many of my friends have been schoolteachers. A few openly share how hard it is to keep the children interested in course subjects. One of my friends was working in an inner-city high school. He told me that many of the students didn't stay focused on the daily tasks. He went as far to say that he called a few of the parents who would not intervene. He was stuck trying to come up with an idea on how to make learning fun.

I spoke about how I found creating rap therapy one of the best assets in my work. It helped me connect with the inner city children I worked with. Many had been through the foster care system. In the beginning, the differences between us were clear. I had come from a middle class background and was dressed quite conservatively. They were mostly from

very poor neighborhoods and had seen struggles no youth should be exposed to.

During those days, I found rap therapy as a tool to connect us. When the music and art of spoken word came out, we looked past our differences. Together, we found a common bond through our mutual love of hip hop music. It took time but the lessons grew stronger and more positive. Over a few months, many heavy topics were open for discussion. I saw kids rap and write poetry about losing parents to suicide, having a mom go to jail, seeing a loved one murdered in cold blood, dealing with barely having enough food to eat, and coping with mental and physical abuse.

These topics were real and often more than I knew how to handle. I was a beginning social worker and these are the real truths you cannot learn about in school. How do you help a twelve-year-old who was beaten, lost their parents, and has been kicked out of several homes and schools? What can you say to them to help them have hope? Would I be wrong to teach them that the future could be bright? Would it be a lie to offer them a future that may be less painful than their past?

I contemplated these deep psychological lessons. I was new in my training and doing the best I could. I was also working in a mental hospital that affected my own emotions. Just a few years before, I was locked in a psychiatric hospital several times. I was the patient locked in for a month and having to undergo the same therapies. Could I handle now being a professional and trying to help other young people in situations similar to what mine had been?

I worked with my rap therapy group and it was wonderful. We were creating great talks, music, and songs about their lives. I was trying to show them that expression and

feelings are healthy. They became less embarrassed by their truths as they watched everyone becoming open. We created a safe space to be creative and express our thoughts. As a leader, I found my role was to slowly and calmly help them find their own truth. I could not take away the blistering pains they battled as children. I could only try to help them find the tools to change and reshape their futures.

This all is part of a teacher creating a coloring lesson. My first tip is to copy sheets for students to color. It may be possible to find ones that are interesting and age-appropriate. This may include animals, nature scenes, or even historical figures. When you hand out the sheets it may be helpful to include a few crayons for each student. The cost of crayons is so low that you could give each one a few and not spend a large amount of money. You may even have crayons in your classroom that can be used for this lesson.

The second step is to explain why you are doing a coloring lesson. This may benefit from you explaining why art and creativity are important. You may share a few examples of historical figures that created art.

This will help show students that many historical figures found being creative a way to open up. You may also speak about how as humans we have a need to be inspired. There are many examples of how creativity has led to innovation. We can thank Steve Jobs, Albert Einstein, and Thomas Edison for being deep thinkers. Their ideas helped to change the world we live in. As a teacher, you can share how you also find creativity as a way to move forward.

A part of your lesson should be to teach the class that they don't have to resort to negative ways of handling their emotions. One large part of the addiction problem is that

many children feel hurt. They then seek escape and pleasure through harmful addictions. It may be valuable to remember a few of the wonderful talents we lost too early from overdoses. A few names on the long list include Chris Farley, Jon Belushi, Jimi Hendrix, Judy Garland, Heath Ledger, Jim Morrison, Amy Winehouse, Michael Jackson, and Jean-Michel Basquiat. These terrific talents all left our world way too soon. This will show the students that turning to destructive addictions are a sure way to lose the promise we hold inside.

When the kids begin coloring, you may ask them to think about their emotions. Are they feeling any different during the coloring? Does it help them to relax or slow down their thoughts? You can survey them and ask for a show of hands to the following questions:

Please raise your hand if you felt coloring helped you to feel less anxious.

Please raise your hand if coloring felt better than when learning academic subjects.

If you think coloring could be a fun and healthy daily activity, please raise your hand.

You may see many students with hands raised that are not usually engaging with the class. I was shocked to find some of the most difficult patients interacting during my rap therapy sessions. Even those who were labeled as behavioral problems would often become the most engaged participants during my work. What I found was that some youth who were thought to be causing problems were actually suffering from severe emotional pain. They had bottled up years of troubles. A few admitted that they were so disruptive because they were angry at their families. They felt that

being rude and attention-seeking was the way to basically tell authorities to "fuck off."

The young people I worked with hated authority and were sick of structured activities. It became obvious that being the class troublemaker was the way to seek revenge for their problems. I would find that many wanted to change. They were hurting so deeply that their tough exterior was a cover for severe insecurities. A few said that no other therapist had ever found a way to engage with them on their level. It became easy to see that these types of groups helped make positive changes. I watched as some began to do better outside the group. They were able to be happy and let go of some of the heavy emotional baggage. It was wonderful to watch them interact better with other children and the staff of the hospital.

Do you as a teacher have kids that come across as aggressive? Are you having difficulty teaching the coursework while some are unfriendly, attention-seeking, and hostile? My belief is that doing a coloring class will change the dynamic of the group. You are showing that a non-traditional tool actually may have value. It is also a way to help the students connect with each other.

You may be teaching a future policeman or policewoman in your class. What if they learned to love and respect all people? You may have a troubled youth with the potential to be a school shooter, ISIS terrorist, or dangerous criminal. What would happen if we reached them young enough to help change the course of their future? What would happen if they learned to release their emotions in a positive way? Would you be able to stop the next generation of attacks from happening by improving the mind of a troubled youth? Could we make our society one where love and peace prevail?

These questions are not going to be solidified by a study or anything else today. They are going to be something I will think deeply about. I encourage all of us to look at what is happening around us. If you want to create a brighter future, we have to start helping with problems before they have reached the peak of anger. I have seen some pretty troubled kids turn around their lives.

I believe my work has helped many to avoid some painful outcomes. We need more of this work to shatter the hate that is held deep within many of our minds. We cannot be a society that does not have the power to change. Recent tragic events remind us, again, of all the reasons to change our thinking. We owe it to future generations to create openness and outlets that help us heal. If we do not, these sad occurrences will leave us in a world of chaos. It is not too late to start improving all of our minds.

Chapter 22

A Coloring Experiment

I began an experiment in my home. I set a goal of recording my emotions while doing different coloring activities. I bought a large yellow board at my local craft store. I brought out my bin of markers and crayons. I took a marker and drew several open shapes. They included a circle, rectangle, and triangle. I made them big enough for me to color inside of them.

I started with the circle. My first coloring experiment was to go very fast. I quickly shaded in about a third of the circle. I asked myself what I was thinking as I engaged in this activity. The word energized described how I felt. I felt a rush of energy as I quickly shaded in this part of the circle. My second test was to go more slowly and color in a circular motion. I felt myself relaxing and my brain becoming more calm.

The third step was to color slowly and in a back and forth motion. During this part, I felt peaceful and actually experienced a sensation of chemical release in my brain while coloring. I would describe it as a warm sensation that overtook part of my head. I have felt this feeling before and during

therapy sessions. I also have seen this on YouTube videos titled ASMR. This is a new type of field where viewers feel a tingling sensation in their head while watching someone do something soothing. There are a number of performers who pretend to brush someone's hair, be an airline stewardess, and hundreds of other types of interactions. I have seen people describe this as having a brain orgasm. I felt this feeling while coloring today. I wonder how many who read this have also felt this tingling sensation in their heads?

The next part of my test was to color in a rectangle. I grabbed a pencil and started shading in the shape. During this part, I described my feelings as emotionless. I was not feeling or thinking of anything. It was as though I had left the part of me that was often contemplating different ideas. Then I took a crayon and starting coloring another part of the rectangle. This time I had some thoughts but felt soothed. It was calming to feel the crayon on the paper and the rectangle filling up. The third attempt in this shape was to go up and down. I went back and forth with a red crayon. This time I felt peaceful and happy. I was enjoying the coloring and relaxing.

I next went to the large triangle I drew. This time I would try something different. I grabbed two markers of different colors. One was black and the other was green. I held both of them together in my left hand. I attempted to color while holding on to them both. It was difficult and different than what I am used to. Most of my coloring is with one marker or crayon. While holding two, I used a different skill. I would describe the emotions as curious. This new activity made me feel different, as though I were exploring other possibilities. I then grabbed both markers and colored the

rest of the shape. I described my feelings as having my senses stimulated. I was deeply involved in the activity and felt my energy slightly increasing.

Next I made a drawing of a large square on my board. In it, I placed a circular sun at the top right of the square. I then drew a house with four windows, a roof, and a door. My first step was to take a yellow marker and color in the sun. I felt this was fun and I enjoyed seeing the color yellow spread through the image. I then grabbed a green crayon. I worked to color in the four windows of the home I drew. At that point, I began to feel bored. I finished the first window, and then had three identical ones to color. As my quest continued, I began to feel hopeful. I then set out to color in the triangle roof of the house. I did it in the color blue and tried to do it slowly and methodically. During this coloring, I described my thoughts as open. I felt open to coloring, creativity, and whatever the future might hold.

The final part of this home coloring was to shade in the unused part of the picture. I found a turquoise blue crayon and began gently shading the rest. I felt satisfaction from almost being done. I then had a feeling of being liberated. Here I am, relaxing, coloring, and doing something I would never have thought of a few years ago. I love the fact that I can color and for just a few dollars do something that helps me feel free.

Next I drew an ice cream cone. This time, I would close my eyes while coloring. What would it be like if I were unable to see what I was doing? I started to color and couldn't see a thing. I began to feel anxiety and worried that I would do a poor job. I started to feel out of my comfort zone. It was interesting that even something so simple could make

me nervous. I had never colored without being able to see. It was amazing that this slight change impacted my thoughts so deeply.

I then tried to color the rest of the ice cream cone without opening my eyes. I told myself to just let go and have fun. It took a few moments but I started to feel better. I was now curious to know how my blindfolded art had come out. I opened my eyes to find my creation. I had certainly colored outside the lines and it was fun. I realized I had to stop setting up such rigid rules for what I determined to be correct.

My final part of the experiment was to draw a car. I began to draw a simple car with four wheels. This time, I would use the opposite hand. I am left-handed and write everything with this hand. This time I would take my right hand to color. This was abnormal for me, as I usually color with my left hand.

I started to shade in the top of the car with my right hand. My thoughts began to tell me I could do this. Even though I am used to using my other hand I felt it is possible to do it. I then noticed that I was not as accurate with my right hand. I started to have some of the crayon go outside of the lines. I began to think of myself as doing a sloppy job. This reminded me of when I would put myself down as a youth. I then felt myself saying that I was outside of the lines. This made me a bit frustrated and I realized I did a poor job.

I then began to grab a green marker. In my weaker right hand, I began coloring and shading the whole area. I began to feel the word smooth come across my mind. The drawing and coloring was also making me feel kind. I started to be a little happier and enjoying the activity again.

I reached for a brown crayon to color in the wheels. The first wheel was a very small space. It was hard to color in a small box. The word controlled popped in my head. It was difficult to control my coloring and to be within the small lines. I then began coloring the second wheel. It was larger and more open. As I was coloring, the crayon broke in half. I laughed and thought I should be open to change. I completed this wheel and went to the final two. As I worked, I told myself to be open to change.

This simple experiment taught me a great deal about my thinking process. I learned how so many emotions can come up even in a short coloring activity. I began to see that changing my routine is harder and impacted my emotions. I also learned that we often do things the same way over and over. When I changed hands, was blindfolded, or used two crayons, I was not prepared. I didn't mentally enjoy that I was not used to these experiences. We are often more comfortable doing things the same way again and again.

You could do this same experiment at your home or group. I only used a large poster board, some markers, and crayons. I found this to be enlightening. We rarely record our thoughts or emotions. There is so much knowledge to obtain when we start to analyze our ideas. You may have colored for months without looking at how it impacts you. It may be worthwhile to do this experiment and see if your thoughts are different than mine. The fascinating part of our brains is that we each come up with different responses. You may tap into something surprising and new by recording your ideas.

Chapter 23

The Starving Artist

What does it take to create art that will say something important? The greatest and best known artists often were challenged in massive ways. Did their times of trials and tribulations help them create work that holds value even today? Is the role of an artist one that is synonymous with facing adversity? I began to explore some of the history of the painters who we still study today.

Joan Miró is a perfect example. He admitted at age eighteen he fell into a dark depression. Miró would spend several months in bed. He faced a low period that led him to stop studying business and become an artist. Joan Miró would have many times throughout his productive life that he became emotionally sad.

Paul Gauguin created works that are worth millions of dollars. His life was filled with challenges and obstacles. He had several suicide attempts. Paul was so upset that he left his family and faced extreme money issues. He drank often, contracted syphilis, and had many problems. He was so creative, yet problems always appeared to enter his troubled mind.

Edgar Degas is a celebrated French artist known for his prints, drawings, sculptures, and paintings. He started to lose his eyesight, which caused him to become extremely despondent. This led to isolation and depression that stopped him from being able to create his paintings in the same manner.

An article in the *Journal of Medical Biography* (2004), "Did Michelangelo (1475–1564) have high-functioning autism?" analyzes research suggesting Michelangelo may have had autism. The lead author, Muhammad Arshad, PhD, is a psychiatrist at Five Boroughs Partnership NHS Trust in Great Britain. WebMd.com summarized findings from Dr. Arshad's work in an article called "Did Michelangelo Have Autism?" They quote Dr. Arshad: "Michelangelo met the criteria for Asperger's disorder, or high-functioning autism." He went on to say that the men in Michelangelo's family showed traits of autism. His family found him to be erratic and he struggled to apply himself to subjects. As a youth, he had problems getting along with his family.

The study and article included more evidence for Arshad's thesis. They say he was a loner and had trouble making friends. This includes struggling to show emotions and care for those in his life. An example is Michelangelo not attending his own brother's funeral. Dr. Arshad cites that he would rarely bathe and often slept in his clothes and boots.

The doctor discussed additional symptoms that helped support his opinion. Dr. Arshad says that Michelangelo was obsessed with controlling his work and life. He would give his undivided attention to his work and get very upset when he lost control of his work, finances, or family. These factors combined to make Muhammad Arshad feel justified in believing that there were signs of autism.

I don't know if it is possible to diagnose anyone with a condition hundreds of years after their death. I also find the label of autism slapped on any child who is different. My own son took a long time to speak. The doctors and therapists were ready to give him an autism label as early as age one. My wife and I took our time to let him develop and not fear that he was ill. We are finding that with therapy he is learning and gaining many new words. I wonder if Michelangelo wasn't as sick or autistic as the researcher believes.

The creations of Michelangelo are still talked about today. If we quickly had him labeled as autistic would he have been able to create his masterpieces? Are we supposed to change who people were created by God to be? I am learning that conformity is not always going to be the best option for each human being. We may hurt our future by diagnosing so many as ill. One part of their genius may be their ability to think and act differently.

I agree that many famous artists had severe problems. The names above are not the only ones who faced major problems. William Blake often hallucinated and saw angels, demons, and other visions. Jean Michel Basquiat become addicted to heroin and it caused him great suffering. There are thousands of examples of known and unknown painters that had problems in their lives. It may be that the creative genius in our brains is both a blessing and a burden. If we look too deeply at it, we may find that making art relies on a different kind of thinking.

The artist is creating something that isn't there yet. They must envision what they are going to draw or paint. Many have an idea in their head and then bring it to life. There

are others who have divine inspiration that flashes into their brains. They then take these ideas and create masterpieces.

We cannot fully understand how art is created. Many of the artists whose works we see in museums are studied and viewed for hundreds of years. We marvel at what they thought, why they did it, and what the symbolism means in each piece.

For me, part of the joy in viewing art is not knowing all the answers. We can debate and talk about why the piece was invented. Did the problems or pain help influence the art? What was going on in their minds while they worked? We don't have all the answers and that is part of the fun. We are left to view it and wonder. It may be that our curiosity is what makes it all worthwhile.

I experienced many problems and it has fueled my books. The pain and problems are the juice that has allowed me to have anything worth putting to paper. If I wasn't mentally ill and didn't have so many life issues, my writing may have been dull. I know that the hardest obstacles are the most enjoyable parts of my work. It may be that they help inspire or teach other youth facing mental illness. They feel soothed by reading about someone else who was locked in a psychiatric hospital.

The pain creates the source material. When I can find something worth sharing, it opens up the reader's mind to help comprehend a complex problem.

It may be that these artists also had a similar journey. They fueled the creative passion by channeling the hard issues they lived with. It made them better artists and gave the world material that will last forever. As hard as the struggle has been for so many artists, some knew their suffering would

one day serve a powerful purpose. It doesn't take away the pain, but it may help us identify where they came from. We can look at their art through a lens of clarity. We understand that they faced tragedy, yet kept doing what they loved. In the end, they have passed away but their art has not. It lives on as a testament to their ideas and passion. We cannot deny the contribution they made to our society. It has brought joy and light into the lives of millions of people. The next time you walk into an art museum, you can see the walls filled with painters' greatest creations. They left this world in the flesh but created something that will last forever.

Chapter 24

Art Is a Part of Us

Why is art a part of our lives? What is the connection between our minds and viewing art? A group of University of Toronto researchers studied why we are wired to care about art. Their study spanned seven countries and lasted eight years. They published their article, "Viewing Artworks: Contributions of cognitive control and perceptual facilitation to aesthetic experience," in the online journal *Brain and Cognition* (February 2009). Their findings were amazing and confirmed many of my beliefs.

They talked about the brain's anterior temporal lobe. This is thought to impact how we process ideas in relation to different objects. An example would be how we use a butter knife to place butter on bread. The researchers found when we view art, this part of our brain is stimulated. It leads them to believe that viewing art helps us change the thinking process.

The researchers also found ideas they didn't anticipate. They found activation in the posterior cingulate cortex. This part of our brain has a part to play in our emotions. The

researchers believe it is possible that viewing art impacts our mood. They surmised that seeing art may trigger thoughts of happiness, joy, fear, confusion, exuberance, and many emotions.

Research shows we are definitely affected by the nature of the art. The colors, orientation, and shapes are impacting different parts of the visual cortex. This is why we feel affected when we view art. It is actually changing our brains and thoughts. You may feel different based on the colors, images, and size of the painting being viewed. Their research confirmed the idea that many of us believe. We are impacted mentally when we view art. This may be the reason there are millions of us who visit art museums each year. It is not surprising that so often we have a hobby of viewing art online, in books, and at galleries. The pictures we see stimulate our brains and leave us feeling different.

I have devised some questions to help you think differently about art. What do you feel when you see a painting? Does it help you feel happier, leave you confused, or are you curious? Have you ever seen a painting and then went to learn about the artist? Did you want to know where they came from? Were you curious about their life and wondering about their history? Have you ever collected art? What kind of items interest you?

In my own life, collecting art has been a therapeutic tool. I started about three years ago buying art. I found online there were many paintings selling for millions of dollars. I would look at Sotheby's and Christie's and love the famous paintings they auction. Realistically, I could only afford a catalog and not the millions that a Picasso or Warhol would sell for. I then devised my own way to find affordable art.

I had a patient with an addiction to heroin. He admitted that he was twenty-seven and depressed. He would often sit alone in his garage and shoot heroin. I met him while working at a rehab treatment center. I was his therapist and we had some amazing sessions. I enjoyed working with him and thought he would be able to stay sober. I ended up leaving the job and lost touch with this kind, young man.

Many of the patients at the rehab spoke of a place called Faith Farm. When the patients finish the rehab, they often have nowhere to go. They don't have jobs and many have very little money to afford a place to live. They all spoke about Faith Farm. It is a place where men could go live for one year to stay sober. They were given a place to stay, food, and prayers. In order to pay for these services, there was a store that sold donated items.

I would often go there and look for clothes. They also had hundreds of amazing books. In addition, they had real paintings that families had donated. I would go every week and check out the amazing items. It made me happy to know anything I would buy would help support addicts in recovery.

One day, I noticed my former patient. He was now living at Faith Farm and hoping to stay clean for one year. In order to stay, he had to work as a clerk in the store. We had a great discussion and I was so happy to see him sober. I would go every week and buy art but also visit him. I was so pleased that he was rebuilding his life. I also ended up owning about thirty paintings, signed prints, art books, and even a sculpture. I would sometimes find something by a famous artist for just a few dollars.

This began my hobby. I found myself feeling so joyous and peaceful as I searched through the art. I would look

online to see if the artists had anything written about them online. One day, I found a beautiful signed print with the initial G. H. Rothe. I discovered that she is a world famous artist. The item I bought was a mezzotint. Rothe was born in Germany and is one of their greatest artists.

I reached out to a famous gallery in Germany that sells many Rothe items. It was exciting as I waited to hear back from them. They told me I indeed had an authentic mezzotint from the renowned artist. When they told me it was worth $8,000, I almost fell off my chair. This meant my find was worth over one hundred times what I paid for it! I felt like a contestant on a game show. I continued to enjoy my hobby, never knowing what to expect.

The art we enjoy is not just paintings or art in museums. There are so many types of art in our lives. Steve Jobs was an artist with his team at Apple. The products they make are creative and push the design elements to a new level. There are architects who build homes and buildings that convey such creativity. We view the creations with awe and excitement. I often buy toys for my children. I see the designs and drawings on the box of each product. When I watch cartoons with my kids, I see the art of the animators. The writers also create dialogue and stories that help my children feel joyous.

It may sound odd, but I see art in unusual places. I often do nature walks and feel as if I am in a painting. I view huge large trees that are open and green. I see purple and blue flowers that look like God painted them. I watch as leaves and grass on the ground make a soothing picture and sound as I walk. This tells me how beautiful our world is. We can feel art in each day of our lives.

I don't know how to describe the way art has impacted my life. I only find that it makes me happier and joyous. I have a room in my home where I am creating much of my work. It is filled with the art books, paintings, and other items I love. When I see them it helps me slow down and feel alive. I embrace the many different artists represented in my collection. These items bring me joy and hope.

Once a month, I take a look at all the art books I own. Many are filled with amazing pictures. I see how photographers are artists and admire the images they have captured. A few of the books capture animals in nature, the people of the city of Boston, a day in the life of living in Hollywood, images of Claude Monet's works, and drawings of angels. Each one is so interesting. I find this time helps me be connected to a creative source. If I am ever struggling to find inspiration, I open up one of these books. I then can view the geniuses who shared what they captured.

We can all find ways to bring art into our lives. Many are allowing coloring to help them enjoy this art. There are some who start with coloring and end up drawing, painting, and sculpting. This is why I call adult coloring a gateway drug. You may start with coloring and then end up a full-fledged artist. This could include making, viewing, collecting, and loving art. I don't think any of us will overdose on our creative passion. It may help us feel more alive and actually appreciate the art all around us.

Chapter 25

Learning to Change May Be Strange

I know much of our lives are serious. We worry about moving ahead in our careers, finances, relationships, and achievements. Our culture celebrates the ones who have made massive accomplishments. We read about their success and some of us secretly wish we could obtain these rewards. It is not wrong to have high hopes for yourself. I have found that intense, dramatic change often is a strange and challenging experience.

It sometimes happens that we shift in the most unusual ways. I was working with a woman named Matilda. She was struggling with anxiety and insecurity. We spoke about cognitive ways to help improve her thought process. I shared a number of tools to encourage her to think differently. My ideas included a gratitude chart, deep breathing, say affirmations, and working out more often. These are items I use often to help many types of families and individuals.

Matilda tried all these strategies to feel less anxious. She reported that nothing was working. It was becoming obvious that she was frustrated with her therapy sessions. It was

her time and money and she wanted results. Matilda complained that she had been to counseling several times before. She always tried to change but would still have a persistent level of anxiety. This included seeing a psychiatrist who prescribed medication to reduce her fears. Whatever she tried, it would not work.

I was doing my best to help her. I had tried all the normal ways I know to assist someone with anxiety. It concerned me that she had been trying for years and that nothing was working. I began to secretly wonder if this work was worthless. I have found over many years a very fascinating lesson about helping others. It is that patients usually only change when they are open to the help.

If they think it is all bullshit, then they will keep living the same way, repeating the same negative patterns. I only provide the tools to do things differently. It is up to the individual to actually follow the steps we work on in sessions. So where would I go with Matilda? Was there really any true way to assist her? Did she actually want to change? The last question needs a further description. This sounds horrible, but I have found to be true. There are some who secretly don't want to let go of their pain. Being unhappy gives them an identity. It is weird but something inside them enjoys feeling upset. They fear that if they change it may be too different.

I had a psychiatrist that I would refer others to. The doctor was wonderful at helping find the right medications for those who needed it. Matilda made an appointment and went off to see the doctor. They spoke at length and Matilda was given a medication to help her. The doctor felt she had both anxiety and depression. The goal was to help lessen the nervous feelings while boosting her mood.

The strange part of this example was when Matilda came back to see me. She was so nervous and shaking. I asked her what she was feeling. She said, "I can't take it. I feel happy and calm. This is freaking me out." I then started to tell her that she was achieving her goal. She was less scared and more joyous. She continued, "This isn't me. I'm not happy. I'm not calm. I can't take feeling this way."

I was blown away by her description. We continued to talk and discuss the issue. It turned out that Matilda had lived for forty years almost always filled with fears. She grew up and felt comfortable in her sad state. When she was made to feel happier, it ended up making her feel worse. We spoke about her options. I told her that she would have to slowly learn to accept feeling better. It took her a number of months but it began to work out. Matilda found for the first time in her life a new way of living.

It never occurred to me that she would be uncomfortable feeling calmer. I then understood that changing our thoughts actually changes our whole lives. Many of our friends, ideas, and lives come from what we feel. Once we begin to shift, it can present a scary future. It leave us feeling concerned about what we have to let go of in our lives.

Chris was another client whose changes were strange and almost shocking to me. Chris grew up in an abused home. His mom and dad were both severe alcoholics. Each night, they drank whiskey and vodka. They grew aggressive and sometimes violent. Chris talked about being beaten and verbally abused.

He also shared that each morning his parents were hung over. Chris grew to be a caretaker and was always trying to cheer up his parents. They were so negative that Chris would

always try to find a way to cheer them up. It was a negative way of living but Chris knew nothing else. He began to feel upset after he left home to attend college.

Chris then began therapy and for the first time opened up about all he had faced. There was another big problem. Chris had about ten friends that were his inner circle. They all were heavy drinkers and negative people. He would try to cheer them up and turn their negativity into feeling better. This was also abusive, as many of the friends would call Chris horrible names. When they drank, they called him "weird, nasty, a faggot, nigger, fag boy, and Uncle Ben."

He admitted this was wrong. We began a long process of dealing with, and healing from, these painful emotional scars. I told Chris that he deserved to be around healthy people who appreciated him. Chris stopped drinking and became a member of Alcoholics Anonymous. He started to see he was a great man with a bright future.

Chris was finishing up college at a great school. He had studied finance and was offered several positions at a prestigious bank. Chris came in for what would be our last session. In the previous one, he was considering three lucrative offers to work at a bank. He would be moving to Manhattan and would be starting his new job. I was excited for him and happy he had achieved so much.

We started to talk and he seemed extremely happy. He told me he had a big announcement. Chris would not be taking any of the banking positions. He had decided to go to India. Chris had begun studying Buddhism and had discovered Buddhism offered many insights relevant to his life and teachings he felt compelled to pursue. Chris bought a ticket and headed to Dharamsala. He found out that the

Dalai Lama lived there with many monks. Chris planned to spend at least one year living in India.

He knew nobody and had no real plan. Chris just bought the ticket and left. I never saw him again, but I knew his transformation was complete. He went from living with negative and angry people to changing his whole life. I hope he found a peace and joy that only comes with accepting your true self. It may have seemed strange that he would give up material success for a goal that may hold even more value: happiness.

In my own life, there have been times where strange experiences shifted my thoughts. I noticed a few years ago that I see white birds when I am in a good place mentally. I don't exactly know why it happens. If I am doing or thinking well, something magical happens. I will see white birds, a butterfly, or even a rainbow.

The strangeness has become normal in my life. My only brother Adam died of a heroin overdose three years ago. He was my best friend and one of the coolest people I ever knew. Adam was filled with energy and so creative. When he died, I felt a part of me slipping away. His death could have led me into a dark depression. It hurt so bad to know he was gone.

The way he died also bothered me. He did one needle, fell, hit his head, and died. I wasn't there when this happened to him, but the thought of my brother lying in a pool of blood horrified me. I know his roommate found him the next day and had to witness the body. It was too sad and upsetting for me to know that these were my brother's final moments.

I began a series of strange changes because of his death. I stopped drinking completely when he died. It has been three

years since I have had a drink. I plan on having a lifetime of sobriety. His death showed me that we must take care of our minds and bodies. I also began an extremely active fitness plan. I do five to six days of intense workouts each week. This includes sometimes going in the extreme heat to work out. I have built my body to the highest level of fitness I have ever achieved.

The other changes may seem far out and hard for others to understand. I have come to accept them and believe them. My brother used to drive a Jeep Wrangler. He loved to have the car's top down. He would take it to the beach, snowboarding, concerts, or wherever his adventures would lead. I know his car was a positive part of his life.

Now, when I see Jeep Wranglers, it is my sign that my brother is watching over me. This past week I saw a Wrangler with massive tires and hydraulics. I laughed as I thought of my brother sending me an over-the-top car. I even believe Wranglers that he sends mean something specific to me. When I see a white one, this is similar to the white birds. It is a sign that I am doing well and am on the right track. When I see a dark color it may mean that there is dark energy around and to be careful. The yellow ones symbolize that I am buzzing in my career and life. I find that opportunities start happening when I see these. This all may sound weird but it gets worse. I now work part-time selling real estate. I have always had an interest in owning and renting homes. A few months ago, I obtained my Florida real estate license. I now work every Saturday at a real estate office in my town. It is fun showing people homes and a great way to make extra money.

I was working last Saturday when I left my office to show a property. It was an adorable couple that still lived at with

their parents. They were anxious as it would be their first apartment they would be moving into together. Working as a realtor, I also used my therapy skills to help calm them down. I was to meet them at 3 p.m. at one of the apartment communities.

They told me they were running thirty minutes late. I had some time to kill and noticed I was right near my local Barnes & Noble bookshop. I went in and began to browse the books. I was enjoying myself when a strange voice popped in my head. This rarely happens but it said, "Go over to the psychology section. Pick out a book I lead you to without looking at the books."

This was very strange. My training would tell me to forget and ignore the thought. I decided to break conventional rules and listen. I walked over to the psychology section feeling led. I looked away and randomly picked up a book. What would I find? Am I crazy for listening to this silly voice? Do I need to call my doctor for some help?

I grabbed the book and my eyes began to bulge. The author's name was Adam Philipps. I was shocked because my dead brother's name is Adam Philip Wachtel. Adam Philip is his first and middle name. There are no authors named Adam Wachtel. This was as close as it could come to finding a book that my brother would send to me. I cry right now knowing that this was a sign from him. It feels strange but he communicates with me in unknown ways. There is no science to prove how I could feel called over to a section of a bookstore and pull a book without looking.

The scientific odds of pulling the only book with my brother's first and middle name has to be one in 10 million. I have confidence that it was no random act. What do we

do if there are strange parts of our lives that we cannot fully understand? I googled my brother's name Adam Wachtel. I was looking for any obituaries or other items from his life. A big result came up from *The Boston Globe*. It said "Adam Wachtel, 45: banker dealt in currency of charm, geniality."

This was not my brother, but another Adam Wachtel. He shared many similar characteristics. The article quoted his wife who said, "He was quite a character. He was vivacious and exciting, extravagant and generous." It went on to talk about how he always had amazing adventures and made friends with librarians and bus drivers. This would describe my brother to a T. Here was another Adam Wachtel that also died too young. He left a huge mark on others just as my brother did. Is this just a random coincidence or is there a reason they are similar?

There are too many parts of our minds we do not know. I often think of an old friend and within moments they are calling me on the phone. I began to think about something bad happening in Orlando in early 2016. A few months later, a terrorist murdered forty-nine people and wounded fifty more at a gay nightclub. Are these random coincidences? Is it possible that there is so much more to learn and understand about our minds? Should we call these thoughts crazy or genius?

I do not have all the answers but I encourage more open dialogue about these topics. I should not feel shame as a professional openly sharing these ideas. I believe many of the readers of this book will have their own examples of strange types of thinking. I have learned that this is not wrong or immoral. We must learn to be open to what we cannot feel, see, or touch. Our world is filled with answers to questions we haven't even yet contemplated.

I am now happier because I am open to bizarre ideas. I felt so peaceful when I found the book that my brother sent me. I secretly miss him so much. I feel terrible that there was no way to save his life. I have helped countless individuals and families make better choices. I could not save my only brother and I used to wonder if there was more I could have done. When I am sent these messages it is his way of telling me it is okay. I relay the story to my whole family. We connect knowing that Adam can reach us on the spiritual realm. It will never heal our wounds but it may bring some light into our lives.

You may be going through your own set of struggles. It is my sincerest wish that life works out for you in the most positive way. It is possible to transform how we choose to respond to problems. One of the lessons I follow is to be open to change. I used to be so rigid and want to have control of everything. I only found peace when I accepted that I don't have ownership of the future. I also believe that even the most painful experiences have the power to help us change. It may be that strange and sometimes weird events are going to happen. We can find love and hope in even the most bizarre times. We may look back and find it opened us up to something new and better.

Chapter 26

A New Path Forward

How does coloring lead to a new path forward? I suggest that in it we can find the joy and creativity to build a world that is beautiful. We can decide if we want to find negative or positive views of our own lives. The reality is not in what happens, but our decision about our response.

I bring this back to my study of Kaballah. The ancient Jewish rabbis understood many important concepts. Kaballah is powerful in sharing about how we respond to life. Every situation is an opportunity to decide how we react. When I first read this it was confusing. Aren't there some situations that are horrible? Where is the light in an innocent person being killed? What is so positive about policemen being murdered in revenge? There are so many daily news stories that could be viewed as anything but hopeful.

This led me to rethink Kaballah's teachings. I do find certain things to be upsetting. I am finding that my response determines my life. I began to watch the news late last week. They were talking about the black men killed by police. This was followed by a black man assassinating several policemen

in Texas. I watched Fox News and CNN. They both had commentators and speakers airing their views. A great amount of the coverage was angry, hostile, and seeking revenge. I was sucked in for a few hours and began feeling upset.

I then started to have questions in my mind. Would more black people be killed this week by the police? Would more police be murdered for revenge? How would I feel as a father if there was a civil war in our country? Would I be forced to pick a side and be a soldier? I am sure I am not the only American who had these thoughts.

I turned off the news and have not really watched since. I am not downplaying the importance or severity of the problem at hand. I know there are nightly protests all around the country. I find if I think too much about these tragedies too much, it becomes more difficult to function. I cannot take care of my kids and responsibilities if I am not well. This has made me focus on other daily activities. I have been writing, reading, playing games with the children, cooking, cleaning, and taking care of them.

Am I wrong? Am I naïve to not be watching every moment of what is happening in our world? Do I owe it to everyone who was killed to focus on it all day long? Do we need a civil war before it will go away? I accept that I don't have all the answers. I also accept that anxiety will only make it worse. You cannot find answers just from worrying and thinking about the fear. These problems have been going on for many generations. I also think there are some who are so upset by our economy that they want revenge. I don't know what to tell them or how to create peace.

The only peace I can create is in my own mind. This starts by focusing on what I love. This is my family, friends, and

activities that help me move forward. I worked out this morn-
ing and the one hour felt terrific. I also have been coloring
and painting in my garage. I am finding this to be a healthy
distraction. When I am creating, I am not fearful. I live in the
moment and don't worry about tomorrow. I also find that my
kids are having fun drawing and coloring. My daughter loves
being creative. She spends the evenings drawing, making vid-
eos, playing with the neighbors, and relaxing.

This is my version of choosing my response. If you asked
my seven-year-old about what is happening she may not be
able to tell you. She has not been watching her dad nerv-
ously focusing on the news. I have a wife who grew up differ-
ently. Her dad watches CNN and Fox News for a good part
of every day. Her dad would talk about how we are going to
have a civil war. He would likely say that lots of people will
be killed. He would talk about how nowhere is safe and we
are all doomed.

My wife and I are choosing to give our kids a different
way of growing up. We may be wrong, but it is our decision.
I am proud that my daughter has a positive and optimistic
outlook. I don't want her to live in fear or concern. The real-
ity is always what you make of it. On my block we have two
children that are my daughter's close friends. One is African
American, another is Spanish American. They hang out all
the time. They had a party in my garage recently. They were
coloring, playing a pie in the face game, listening to music,
and being kids. They were happy and nobody cared who
was from where or what color their skin was. They were just
three friends.

What would happen if future generations grew up feeling
equal? My daughter loves all people—as she should. She has

been taught to judge a person by their actions and not the color of their skin. If more of us taught our kids this, what would we create tomorrow? Would we build a society where creativity is part of every child's curriculum? Would we grow to be a nation of joyful and peaceful people?

I don't know all of the answers. I do know that hatred is not working. We cannot hate others and find love. We cannot judge and find hope. If we don't move forward the negative outcome will grow worse. We already have so many problems that can be bring us down. What if we find a way to lift ourselves up? This would mean creating a future that is not one of loss. It is a time where we grow to be a higher version of where we are right now. It doesn't start just with a protest or a news article. It begins with our thinking and then our actions. We make a decision each day to decide what happens in our lives. These small changes within yourself create a ripple effect. It impacts your family, friends, and community, and may just end up changing the world.

Chapter 27

Art Quotes

There are so many artists that have contributed to our world. I want share a small, okay, perhaps not so small, sample of some of their thought and ideas. This chapter isn't meant to be read in one go. Think of it more as a repository for inspiration when you sit down to color or do some other creative activity. Dip in, find one or two that speak to you, then carry their message with you. No problem if it doesn't light your fire. There are many more to choose from. This section has quotations from many different figures from many different genres. Many are no longer with us, but their ideas and works still live on to this day.

"Everything you can imagine is real."
—Pablo Picasso

"This is my simple religion. There is no need for temples; no need for complicated philosophy. Our own brain, our own heart is our temple; the philosophy is kindness."
—Dalai Lama

"When I was fifteen, I left school to start a magazine,
and it became a success . . . I was a fifteen-year-old with
passion . . . Making money was always just
a side product of having a good time and creating
things nobody'd seen before."
—Richard Branson

"This is the key to life: the ability to reflect, the ability
to know yourself, the ability to pause for a second before
reacting automatically. If you can truly know yourself,
you will begin the journey of transformation."
—Deepak Chopra

"Stop blaming your spouse for your unhappiness, your
parents for your lack of motivation, the economy for
your social status, your childhood for your phobias, and
anything else to which you assign blame points. You're
the result of the choices you've made in your life."
—Wayne Dyer

"Every child is an artist. The problem is how to remain
an artist once he grows up."
—Pablo Picasso

"The way I make art—the way a lot of people make
art—is as an extension of language and communication,
where references are incredibly important. It's about
making a work that is inspired by something preexisting
but changes it to have a new value and meaning that
doesn't in any way take away from the original—and, in

fact, might provide the original with a second life
or a new audience."
—Shepard Fairey

"I encourage everyone to become their dream.
Most young people get sidetracked and never end up
doing what they really set out to do."
—James De La Vega

"Art is about emotion; if art needs to be
explained it is no longer art."
—Pierre-Auguste Renoir

"Why am I doing the work I'm doing? Why am I
friends with this person? Am I living the best life I
possibly can? Questions are often looked upon as
questions of doubt but I don't see it that way at all. I
question things to stay present, to make sure I'm
doing what I'm supposed to be doing."
—Joseph Gordon-Levitt

"Men have died for this music. You can't get
more serious than that."
—Dizzy Gillespie

"Progressive art can assist people to learn not only
about the objective forces at work in the society in
which they live, but also about the intensely social
character of their interior lives. Ultimately, it can
propel people toward social emancipation."
—Salvador Dali

"The thing is, if you believe in the unconscious—and
I do—there's room for all kinds of possibilities that I
don't know how you prove one way or another."
—Jasper Johns

"The world breaks everyone and afterward many
are stronger at the broken places."
—Ernest Hemingway

"Great spirits have always encountered violent
opposition from mediocre minds. The mediocre mind is
incapable of understanding the man who refuses to bow
blindly to conventional prejudices and chooses instead
to express his opinions courageously and honestly."
—Albert Einstein

"It's the game of life. Do I win or do I lose? One day
they're gonna shut the game down. I gotta have as
much fun and go around the board as many times
as I can before it's my turn to leave."
—Tupac Shakur

"People worship the painting of an artist and don't
know anything about the man. I never get conceited
about my work because the paintings are not me.
And no matter how hard an artist tries, it can
never be good enough."
—Willem De Kooning

"The advice I like to give young artists, or really
anybody who'll listen to me, is not to wait around for

inspiration. Inspiration is for amateurs; the rest of us just show up and get to work. If you wait around for the clouds to part and a bolt of lightning to strike you in the brain, you are not going to make an awful lot of work. All the best ideas come out of the process; they come out of the work itself. Things occur to you. If you're sitting around trying to dream up a great art idea, you can sit there a long time before anything happens. But if you just get to work, something will occur to you and something else will occur to you and something else that you reject will push you in another direction. Inspiration is absolutely unnecessary and somehow deceptive. You feel like you need this great idea before you can get down to work, and I find that's almost never the case."
—Chuck Close

"People come to me to be photographed . . . Time stops. We share a brief, intense intimacy. It has no past . . . no future. And when the sitting is over—when the picture is done—there's nothing left except the photograph . . . I don't feel I was really there. At least the part of me that was is now in the photograph. And the photographs have a reality for me that the people don't. It's through the photographs that I know them."
—Richard Avedon

"If you want to know all about Andy Warhol, just look at the surface of my paintings and films and me and there I am. There's nothing behind it."
—Andy Warhol

"Making art, good art, is always a struggle. It can make you happy when you pull it off. There's no better feeling. It's beauteous. But it's always about hard work and inspiration and sweat and good ideas."
—Damien Hirst

"Yes, you know sometimes, we started out thinking out how strange our painting was next to normal painting, which was anything expressionist. You forget that this has been thirty-five years now and people don't look at it as if it were some kind of oddity."
—Roy Lichtenstein

"I showed the America I knew and observed to others who might not have noticed."
—Norman Rockwell

"We keep moving forward, opening new doors, and doing new things, because we're curious and curiosity keeps leading us down new paths."
—Walt Disney

"A great photograph is a full expression of what one feels about what is being photographed in the deepest sense, and is, thereby, a true expression of what one feels about life in its entirety."
—Ansel Adams

"The greater danger for most of us lies not in setting our aim too high and falling short; but in setting our aim too low, and achieving our mark."
—Michelangelo

"You can't make either life or art, you have to work in the hole in between, which is undefined. That's what makes the adventure of painting."
—Robert Rauschenberg

"Everyone discusses my art and pretends to understand, as if it were necessary to understand, when it is simply necessary to love."
—Claude Monet

"Graffiti is a lot easier than the canvas actually, because it's such a large format, so when you're going to such a thin detail, it's not that thin in the realm of things because it's such a big wall."
—Alec Monopoly

"They call me the painter of dancers. They don't understand that the dancer has been for me a pretext for painting pretty fabrics and for rendering movement."
—Edgar Degas

"What I dream of is an art of balance, of purity and serenity, devoid of troubling or depressing subject matter, an art which could be for every mental worker, for the businessman as well as the man of letters, for example, a soothing, calming influence on the mind, something like a good armchair which provides relaxation from physical fatigue."
—Henri Matisse

"Right now a moment is fleeting by! Capture its reality
in paint! To do that we must put all else out of our
minds. We must become that moment, make
ourselves a sensitive recording plate. Give the image
of what we actually see, forgetting everything that
has been seen before our time."
—Paul Cezanne

"If you hear a voice within you say 'you cannot paint,'
then by all means paint, and that voice will be silenced."
—Vincent Van Gogh

"Nothing is absolute. Everything changes, everything
moves, everything revolves, everything flies
and goes away."
—Frida Kahlo

"Experience, the interpreter between creative nature and
the human race, teaches the action of nature
among mortals: how under the constraint of necessity
she cannot act otherwise than as reason, who steers
her helm, teaches her to act."
—Leonardo Da Vinci

"In every great time there is some one idea at work
which is more powerful than any other, and which
shapes the events of the time and determines
their ultimate issues."
—Francis Bacon

"I start a picture and I finish it. I don't think about art while I work. I try to think about life."
—Jean Michel Basquiat

"The modern artist, it seems to me, is working and expressing an inner world in other words – expressing the energy, the motion and other inner forces."
—Jackson Pollock

"In earlier days, even as a child, the beauty of landscapes was quite clear to me. A background for the soul's moods. Now dangerous moments occur when Nature tries to devour me; at such times I am annihilated, but at peace. This would be fine for old people but I . . . I am my life's debtor, for I have given promises."
—Paul Klee

"For as long as I can remember I have suffered from a deep feeling of anxiety which I have tried to express in my art."
—Edvard Munch

"Whoever wants to know something about me—as an artist which alone is significant—they should look attentively at my pictures and there seek to recognize what I am and what I want."
—Gustav Klimt

"My aim in painting has always been the most exact transcription possible of my most intimate impression of nature."
—Edward Hopper

"Artists create out of a sense of desolation. The
spirit of creation is a excruciating, intricate
exploration from within the soul."
—El Greco

"Every good composition is above all a work of
abstraction. All good painters know this. But the painter
cannot dispense with subjects altogether without his
work suffering impoverishment."
—Diego Rivera

"Art to me is an anecdote of the spirit, and the only
means of making concrete the purpose of its varied
quickness and stillness."
—Mark Rothko

"What I am seeking is not the real and not the
unreal but rather the unconscious, the mystery of the
instinctive in the human race."
—Amedeo Modigliani

"I hope that my painting has the impact of giving
someone, as it did me, the feeling of his own totality, of
his own separateness, of his own individuality."
—Barnett Newman

"Every child has the spirit of creation. The rubbish of
life often exterminates the spirit through plague and a
souls own wretchedness."
—Peter Paul Rubens

"Painting done under pressure by artists without the necessary talent can only give rise to formlessness, as painting is a profession that requires peace of mind."
—Titian

"The act of creation is a kind of ritual. The origins of art and human existence lie hidden in this mystery of creation. Human creativity reaffirms and mystifies the power of life."
—Keith Haring

"To my mind, one does not put oneself in place of the past; one only adds a new link."
—Cy Twombly

"Everything is mere appearance, the pleasures of a passing hour, a midsummer night's dream. Only painting, the reflection of a reflection—but the reflection, too, of eternity—can record some of the glitter of this mirage."
—Edouard Manet

"Since there is no such thing as absolute rightness and truth, we always pursue the artificial, leading, human truth. We judge and make a truth that excludes other truths. Art plays a formative part in this manufacture of truth."
—Gerard Richter

"I believe that my art gets across the point that I'm in this morality theater trying to help the underdog, and

I'm speaking socially here, showing concern and
making psychological and philosophical statements
for the underdog."
—Jeff Koons

"I never know what I'm going to put on the canvas. The
canvas paints itself. I'm just the middleman."
—Peter Max

"It's interesting how people who were once fairly
radical can become, later in life, kind of conservative,
and not just in terms of politics—how, if you're an
artist, you can start out being somewhat avant-garde
and then end up doing landscapes."
—Richard Prince

"The artist is not responsible to anyone. His social role
is asocial . . . his only responsibility consists in
an attitude to the work he does."
—George Baselitz

"We tell them that we believe it will be beautiful because
that is our specialty, we only create joy and beauty. We
have never done a sad work. Through the drawings, we
hope a majority will be able to visualize it."
—Christo

"I love those who can smile in trouble, who can gather
strength from distress, and grow brave by reflection. 'Tis
the business of little minds to shrink, but they whose

heart is firm, and whose conscience approves their conduct, will pursue their principles unto death."
—Leonardo da Vinci

"The big pay-off was to work as an artist and gain some shred of respect from your friends, who were also artists. But there was never any notion that you could make a living out of art. On the rare occasions you had a gallery show, and sold a little work, well, that was just gravy."
—Edward Ruscha

"I prefer the emotion that corrects the rule."
—Juan Gris

"The great problem was the selection of the ready-made. I needed to choose an object without it impressing me: that is to say, without it providing any sort of aesthetic delectation. Moreover, I needed to reduce my own personal taste to absolute zero."
—Marcel Duchamp

"Graffiti's always been a temporary art form. You make your mark and then they scrub it off."
—Banksy

"The purpose of art is washing the dust of daily life off our souls."
—Pablo Picasso

Chapter 28

More Questions than Answers

When I began writing this book, I was hoping to explore a great amount of research. My hope was there would be hundreds, if not thousands, of studies about the therapeutic value of art. I wanted to know exactly how our brain handles and processes art. I came to the conclusion that there is a greater need for research on these topics.

I know that there is a major need to understand how our brains work. In clinical practice, much of the treatments for brain diseases are based on assumptions. Why don't we have an accurate scanning method to pinpoint what is going wrong in the mind of a person with mental illness? Why can we not tell exactly what parts of the brain are stimulated by viewing art? How come we are unable to know how drawing and coloring changes our thinking and functioning?

I would never claim that I have all the answers. This book was meant to consider what seems to be a very simple topic. It is only coloring for adults, right? It should be so easy to prove that coloring makes life happier and healthier. It turns out something so basic still generates confusion. There are art

therapists who are angry that some assume this can replace their work. There are others who think coloring has no therapeutic value and is just a distraction. I am in the camp that believes there is some value in both coloring and art.

It seems strange we have so many unanswered questions about our minds. It is just a small area in our head. You would think we could figure it all out already. It seems that this area is one of the most complex. There is so much left to understand. I am wondering if there is something about our lives we are not meant to grasp. It may be that whatever created us, doesn't want us to know all the answers.

Where did we come from? How were human beings first made? Is everything in our lives random or is there some divine force that rules our whole life? Do we learn by going through painful problems? Are we all in some way tortured by a life that is remarkably hard? Is there no clear answer that solves all the questions we have?

My mind is often looking for connections. I try to analyze why something is happening. This leads me to always be trying to understand and figure things out. This helps when working with others because I try to determine solutions. It also harms me in that I always want to know how things work. I have been helping others for many years, but I don't truly know how the mind works. I have read the studies and books but it doesn't answer all of my questions. I feel much of it is opinion and there are not enough solid answers.

A great part of our nature is wanting to be in control. We want to think we have all the answers. I look at art and there is a huge amount that remains unknown. When you view a picture, you don't know exactly what it stands for. This is what makes it so creative and exciting. You are not sure of

the purpose but can make your own assumptions. This is true with coloring. When there is something to color in you believe you have an idea. This may mean using crayons or markers to color inside the lines. You end up creating whatever felt best in the moment.

Many of our happiest times are when we lose track of time. We color and forget the reality of our lives. We don't worry about being a parent, being saddled with debts, worrying if our career will improve, fearing racism, global warming, or anything else. It takes us to a place that is peaceful and worry-free. This simple escape provides us with something money cannot buy: peace of mind.

It may be worth studying and analyzing, but the truth is simple. If you feel joyful when coloring, then let it be part of your days. I have faced so much adversity that I need healthy outlets. I know I am not alone in seeking positive ways to handle the rigors of life. It feels so hard often, that there is a need for escape. I don't think I am wrong for suggesting outlets.

The part of our lives that means something is love. It may be the love of a spouse or child. The love you feel when drawing, coloring, dancing, acting, speaking, or having fun. This pure bliss is worth all that we have to face. This is our time. It is when we let go of the problems and allow joy to open us up. We move from fearful and confused, to relaxed and zen-like. If you have ever found this in anything, I encourage you to explore it again.

I used to believe that being an adult meant living seriously. I thought I had to be mature and act like a "man." I then had my own children and now I watch how simply they live. Each day, they are in the moment and loving life. They

forget about problems and just do what feels best. I am now trying to add some of this joyfulness to each day. I want to not think as often and worry so much. I have found that creativity is my portal to peace. It allows me to feel refreshed. I let go of every bad thought and allow nothingness to prevail.

I went to Toys R US with my kids last night. We played in the store and my daughter bought a Snoopy Sno Cone Maker. I had one in my youth and thought she would love it. We came home and set it up. I put ice in it and started to crank the handle. We both had fun while making her first homemade snow cones. This is not rocket science but we were happy. I was enjoying seeing her smile and her thrill about something so basic. She covered the shaved ice with cherry sauce and ate the whole thing. We were together and I felt wonderful. These moments are so valuable and are ones my kids will always remember. I know as I grow older, I will look back and remember that our shared time was important. The pressure, stress, and bills will not be what I focus on in old age. I will focus on the memories and the times we shared together.

I cannot put a price tag on experiences. Each one is a piece of a complex puzzle. When we learn, we grow. The hardest and darkest times of my life helped to make me the person I am today. I am still quite flawed but I believe I am growing. This has meant being able to say my truth and not worry about the ideas of others.

Chapter 29

Real Progress Takes Time

This book opens up a window into where we are. I want to finish this book by sharing a hard-learned lesson. We all look for ways to escape. Many of us are so sad that we worry if anyone can understand us. This leads to isolation and confusion. I know many are secretly depressed and wondering about their futures.

I have another book being released in 2017 titled *The Depression Diet*. This book is a work that was my focus for several years. I began to understand how we are all impacted by depression. I found that it is extremely tough to fight this condition. I learned that 350 million people face depression. It is one of the most costly diseases in the world. Above the material costs are the emotional wounds we carry.

I know we are in a time of depression. Many won't admit it or talk about the truth. I have had conversations with the leaders of large Fortune 1000 companies. They admit that depression is an important topic but few are willing to bring me into their organizations. It seems there is a stigma for a company to admit their employees are experiencing a depression.

Why do we hide from the truth? Do we think that pretending all is well will take away our pain? Is it easier to think happy thoughts than to address our true emotions? I watch on Facebook as friends post glamorous shots from their lives. In private, they share how broke, depressed, lonely, and upset they are. Why are we not saying this publicly? Is it shameful to admit you are struggling? Are we trying to prove we are okay?

I will admit that I am depressed. I seek help and work on it all the time. Each day is a battle to keep going. I do exercise, listen to great motivational talks, and try to persist. I am not ashamed to be open about my pain. If you have faced severe problems, you are far from alone. It is the majority of us who are going through rough situations. We deny this to pretend that we are able to handle it all. I am sick of hiding. I will no longer tell you that life is perfect. I will admit how hard it has been. I tell myself that I need help and go seek it. You may also need assistance. The bravest souls keep trying even when it seems futile. I am no better or worse than anyone who reads this. I am choosing to have the courage to admit there is a problem.

There is a problem, not in America, but in our world. We have created a situation that won't go away. The amount of depression being felt is higher than ever before. There are no simple answers or quick solutions. You won't read a book and be saved. This doesn't mean not to read. It means that change takes time.

Slow and steady growth is the key. It teaches us how to shift our thoughts and behavioral patterns. I have found from studying this for many years, we can actually make changes. It is up to us to come together and improve our world. I

want to live in a place where my kids are happy. I want it to be a world where they have hope and dignity. I dream that they feel love and respect for all people. It includes a place to color, draw, and create. There are no limits on their lives and minds. They can be whoever they dream to be. I don't know if this will ever happen. I will at least try my best to give them a happy home.

Chapter 30

Coloring and Hope

My final chapter is to teach about hope. This is often one of the hardest lessons to learn. The hope we seek is often within us. It begins by making time to care for yourself. When you are coloring, you are creating change. There is evidence that hope changes our outcomes and beliefs.

The research article "Altered Placebo and Drug Labeling Changes the Outcome of Episodic Migraine Attacks," (*Science Translational Medicine,* 2014) details how researchers tested a group of sixty-six patients with migraines. Many of them were given a placebo medication. As has been reported in multiple studies on placebos, many of the patients felt better after taking the placebo. They believed they were receiving a specific medication they had taken in the past and anticipated, based on previous experience, that it would help. While not the answer to all afflictions by any means, the study does validate the notion that thinking impacts our outcomes.

There are so many examples of times when negativity can stop us from succeeding. This is why coloring can be a

great way to rid yourself of unhappy thoughts. I know that some are given a diagnosis that sounds horrible. They may be told there is no cure and that they will go downhill fast. In spite of that, there are cases of individuals who overcame situations that had no cure. We cannot explain these with any exact understanding, but neither can we deny that such "miracles" do happen. I don't always bring religion into discussion because some quickly become offended. I have been listening to Joel Osteen for many years. I find his message and lessons to be one of my main supports, but I also respect that others feel differently. His mother Dodie Osteen has led a remarkable life. She was taken to the hospital in 1981. She was given a diagnosis of metastatic cancer of the liver.

Dodie had a tumor that was very large. It was described as even bigger than a large orange. She began to lose weight and was close to eighty-nine pounds after spending twenty days in the hospital. The doctors said she needed chemotherapy and would likely pass away from the tumor. This woman of prayer would not accept that her life was over.

She went home and, being the wife of a Christian minister, they started to pray and ask God to rid her of the cancer. It is over thirty years later and I saw Dodie twice at Joel Osteen stadium events. I was at the first non-sporting event held at the new Yankee Stadium. I watched in shock as random New Yorkers held each others hands to pray. We came together and had faith that our lives would be improved. Now, I can hear the howls from some already. Let me be clear: I am not saying prayer is better than science. I am not telling you to reject the advances made in medical science. My wife is a physician's assistant and has touched and helped many lives. That's real and it's amazing. But I know

that there have been times that through prayer, faith, and hope I've made it through some tough spots, and I have no doubt many of you have, too. It doesn't have to be either or. And it doesn't have to be prayer. But hope, that amazing gift we all have, is something we should never let go of.

When you believe something can change, it has a greater possibility for coming together. What if all of us came together for the health of our world? What if we colored, sang, danced, and laughed with each other? What would happen if we stopped being angry and hostile? How would our lives change if we felt the light in each other's eyes?

I used to think we were all different. You fit in a certain group being African American, Chinese American, Gay, Straight, Old, Young, Christian, Jewish, or any of the labels we have for our identities. What if we are more than a description? What if there is no way to clearly categorize us? What happens if we don't fit into a pretty box that our culture has created to label and confine us? As I've gotten older, I've come to realize that I don't care to be defined. I don't have to justify what I believe or who I am. Neither do you.

This is true in art and in our lives. We can color and act like a kid. This is not rebellious and it is actually liberating. When we are free to let down our guard, more happiness enters our lives. I want you to hold onto hope in your life. You may have lost so much, but you are awesome. I see you as beautiful, creative, unique, dynamic, colorful, important, and a light to our world. I don't care if you are rich or poor. You may have made mistakes, but who hasn't? You have a glowing soul and creative energy that must be released. Our world needs people just as they are. Since none of us are perfect, we should choose not to judge anyone else. We have

never walked in their shoes and cannot determine how we would have handled their problems.

I find hope in all sorts of silly parts of life. I see hope when my son spoke four words at the same time in his therapy session recently. I watched as his therapist Alejandra and I both marveled at his progress. I had hope six months ago when he barely spoke or had trouble looking at anyone in the eyes. The hope turned into him speaking very well and gazing in others eyes all the time. I feel hope when my seven-year-old daughter told me to let her stay at camp longer in the day. Tyler wants to spend more time with her friends and loves the community camp she attends. I see the hope that my daughter is living a full life filled with friends and simple joys.

I felt the hope when my wife called from the hospital where she works. I know she is helping those with severe urological issues each day. I love that I can help watch our children while she is making an impact on many lives. I feel the hope that I am sitting here freely writing this. Years ago, I could not imagine such a positive outcome for my life. I was once told by the doctors that my prognosis for recovery was bleak.

They described a life of mental hospitals, the inability to finish school, a low chance of getting married, and most likely living in a group home. My mom had hope that I could overcome my bipolar disorder. I sit here filled with the hope that I have been married for over ten glorious years. I have two beautiful children that are lights in our world. I have shared my story with families all over the world. I had the hope that my dreams could become a reality.

When it has been hard I have found outlets, including coloring. I do this with my family and when I am alone. I found

that being creative and coloring has opened up my mind. It has given me joy, passion, and mostly hope. It has shown me that I can create and be accepting of the gifts I possess and nurture. You too have a powerful future. I don't know where you are sitting right now. I cannot possibly understand what you are thinking and feeling. What I know is that you deserve to find happiness and hope. You can open your mind to better ways of living. You can color the anger out of your head. You may color the loss you have been forced to face. It may be that you color just for the sake of nothingness.

It is never too late to start over. I find it fascinating that some religions call you born again. When I first heard this it sounded crazy. I then started to think, *What if I am born again?* What if that can mean whatever I want it to mean? What if I have a shot to start at the beginning again? Is it possible to be and do life differently? I began to start all of my life with a new freshness. In this new life, I now love all religions. I am a human being that values everyone equally. I came to the conclusion that for as long as I live I would love everyone. Even those who did me harm, I chose to love. I felt this so deeply when my brother died. You are wonderful and perfect as you are. Even with our flaws we hold hope in our hearts. I have made many mistakes, but I keep trying to have hope. I will not give up and accept defeat.

As I end this book, I do so in the hope that you explore who you are on a deeper level. It is possible that all the coloring we do is helping us look at our true selves. I value that you are on a path of learning. I have become a teacher because I am trying to learn the lessons in my own life. I don't have all the answers, but I have enough hope to try and find them. I wish you the very same.

ABOUT THE AUTHOR

Blake LeVine began his mental health career as a therapist helping families and individuals. Blake oversaw groups working with brain cancer patients, those in the arts, families facing depression, bipolar disorder, addiction, and trauma. Many of his patients were from leading corporations, including Lehman Brothers, Computer Associates, JP Morgan, Barclays, and other large organizations.

Blake wrote and published *Beating Bipolar* to help teach families and individuals how to live a successful life when facing mental illness. This led to a national tour on-camera with noted television therapist Dr. Drew Pinsky. Alongside Dr. Pinsky, LeVine spoke to more than one million people on a media tour teaching about these topics. Demi Lovato publicly praised the book and mentioned it on her Facebook page.

Blake has volunteered a large amount of time providing free talks for the National Alliance on Mental Illness and the Depression and Bipolar Support Alliance. The attendance at support groups grew on average 400 percent after

his speaking engagements. He has reached families throughout fifty different cities including Napa Valley, Los Angeles, Ft. Lauderdale, San Diego, Mobile, New York, and Miami. Presently, LeVine continues to travel and speak, with upcoming presentations scheduled in San Francisco, New Orleans, Boston, and Santa Fe. In 2016, Blake published the business book, *The Positive Worker: Developing A Winning Attitude at Work,* with the goal of helping improve corporate teams. The book teaches about the importance of persistence and moving forward during challenging economic climates. Blake has been talking to numerous companies, including Campbell Soup, Atlas Van Lines, Carnival Cruises, Dairy Queen, and many other Fortune 1000 companies about doing educational corporate talks on this subject.

LeVine holds a Master's Degree in Social Work from Adelphi University. A few organizations Blake has worked with include the Equal Opportunity Employment Commission, the Salvation Army, Eli Lilly, the National Alliance on Mental Illness, and the Depression and Bipolar Support Alliance. He is the CEO of BipolarOnline.com where he educates and teaches about these topics.

Books by Blake LeVine

Okay Dad, You Can Take the Picture
Like Mother, Like Son
Beating Bipolar
Depression, Bipolar, and Heroin
The Positive Worker

RESOURCES

BipolarOnline.com

Blake created the educational site BipolarOnline.com. On the website each day there are free educational videos. The goal is to provide free lessons about living with mental illness. The site offers many of the ideas and lessons Blake has shared.

He also provides free education on YouTube. There are over 630 educational talks Blake has created on his channel. You may access them by typing Blake LeVine on YouTube.

Educational Talks

Blake has done many talks for organizations, companies, and events. You are welcome to reach out if you feel that Blake would be a fit for your event. The office of Blake LeVine may be emailed at blakelevinecoach@gmail.com.

Feedback

If anyone has read this book and wants to share their thoughts, you are welcome to email Blake LeVine at blakelevinecoach@gmail.com.

ACKNOWLEDGEMENT

I would like to thank all the readers of this book. I also want to thank my wife Jennifer. She has always stood by my side. I want to tell my children, Tyler and Ryan, that I adore them. They have brought so much life into my existence. I also want to thank my mom for being an amazing teacher. My dad Marc has always been wonderful and warm to us. My dad Larry is a creative man who encouraged me to chase my dreams. My sister Chayse is beautiful and wonderful with children. My sister Natasha is an amazing woman who will soon be an elementary school teacher.

I want to tell all my other friends and family how special they are. We may not spend every day together but you have a huge piece of my heart. Without you I would never have been the person I am. I thank you for being in my life and hope to see you again.

DISCLAIMER

The author of this book does not dispense medical advice or prescribe the use of any technique as a form of treatment for physical, emotional, or medical problems without the advice of a physician, either directly or indirectly. The intent of the author is only to offer information of a general nature to help you in your quest for emotional and spiritual well-being. In the event you use any of the information in this book for yourself, which is your constitutional right, the author and the publisher assume no responsibility for your actions.

To preserve confidentiality and privacy, the names and locations of individuals portrayed in this book have been changed. Each example is created as a teaching tool and is not intended to detail actual events.

Note: Many of the stories in this book are true accounts in which the names and identifying details have been changed to protect confidentiality. Others are composites drawn from years of clinical work. The latter are true to the spirit of teaching, although not to the experience of any particular person.